P9-DMI-499

Carving the

NATIVITY

with Helen Gibson

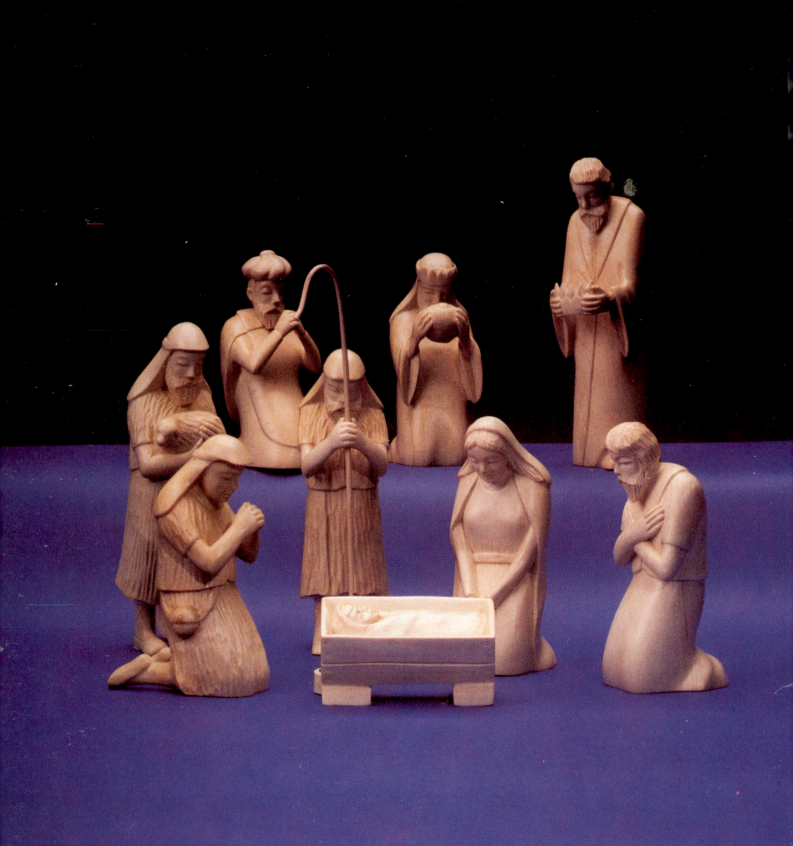

Carving the
NATIVITY

with Helen Gibson

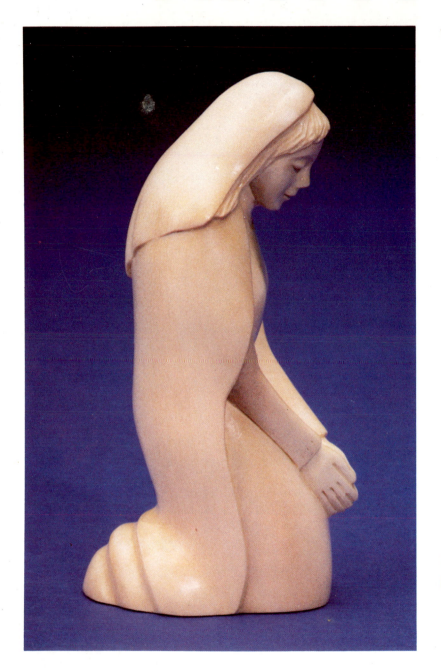

Photography with and text written with
Douglas Congdon-Martin

1469 Morstein Road, West Chester, Pennsylvania 19380

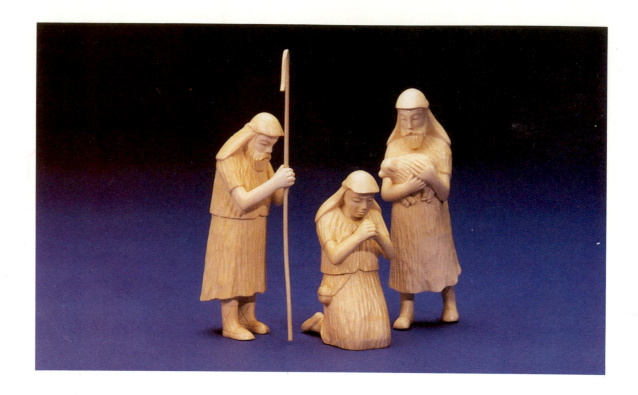

Copyright © 1992 by Helen Gibson.
Library of Congress Catalog Number: 92-60640.

All rights reserved. No part of this work may be reproduced or used in any forms or by any means—graphic, electronic or mechanical, including photocopying or information storage and retrieval systems—without written permission from the copyright holder.

Printed in the United States of America.
ISBN: 0-88740-438-3

We are interested in hearing from authors with book ideas on related topics.

Published by Schiffer Publishing, Ltd.
1469 Morstein Road
West Chester, Pennsylvania 19380
Please write for a free catalog.
This book may be purchased from the publisher.
Please include $2.95 postage.
Try your bookstore first.

If you would like to know more about the history of the Folk School and the Brasstown carvers, there is an illustrated book available from the school. Write: John C. Campbell Folk School, Brasstown, North Carolina 28902

Contents

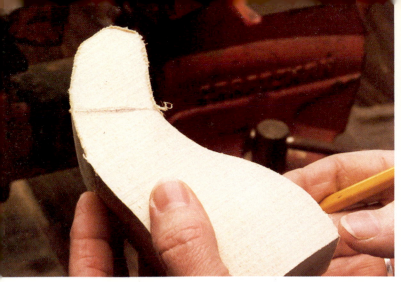

Connect the front and back with a line on the side.

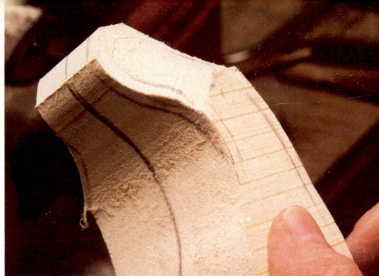

The front.

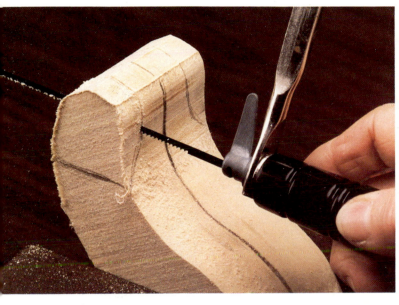

With the piece in a vise, use a coping saw to trim away the waste beside the head.

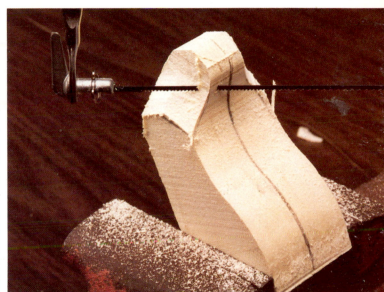

With the coping saw start at the top of the head and remove the front corners...

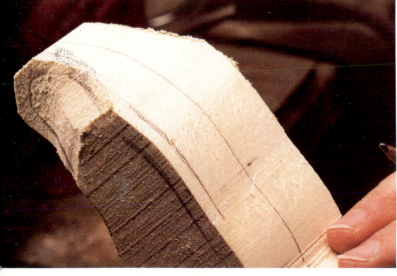

The corners can also be removed with the coping saw. Here are the head profile and back marked...

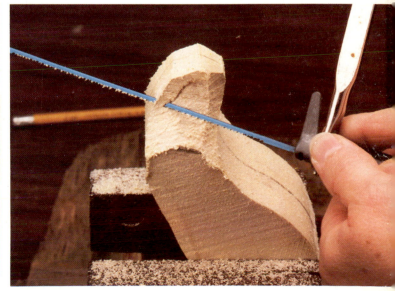

and the back.

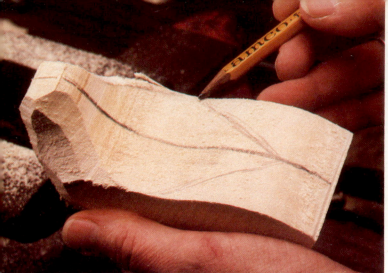

Mark the line of the hands on the front

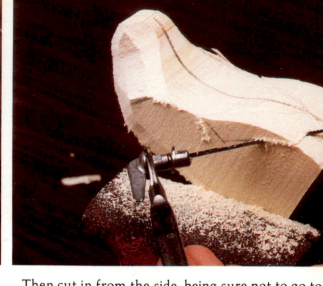

Then cut in from the side, being sure not to go too far, or you will cut into the hands.

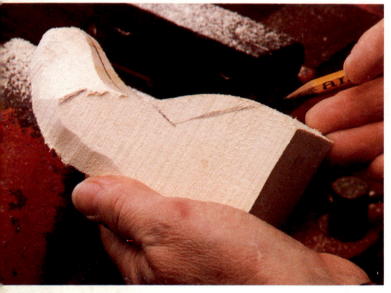

and the sides.

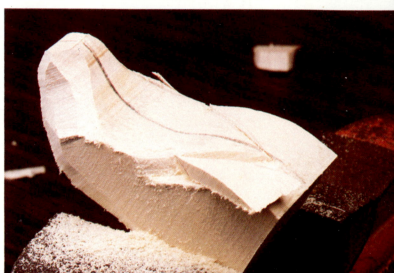

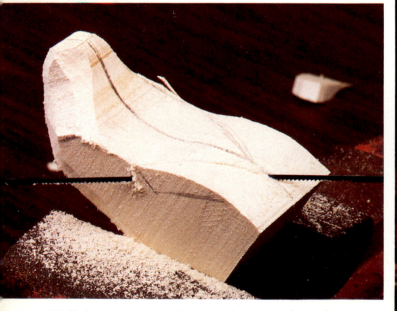

With the coping saw, first cut down the front line.

This removes a triangle like this.

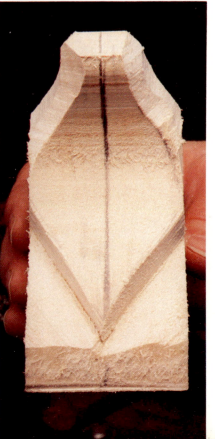

When both sides are cut you should have this shape.

14

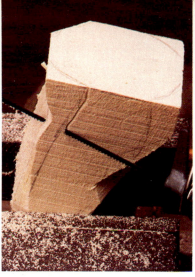

Mark the four corners on the base...

Remove the corners with the coping saw.

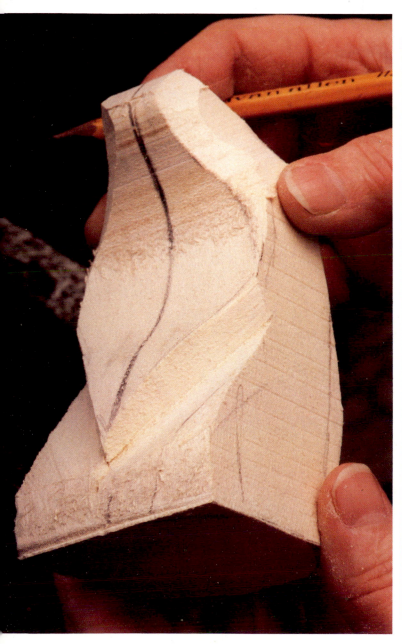

and the sides.

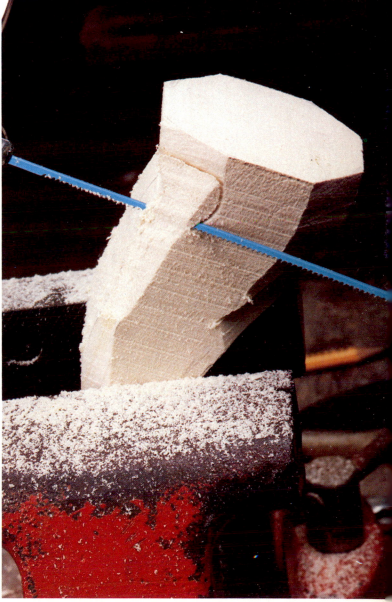

I also cut away just behind the knee in the back with a nice curved cut.

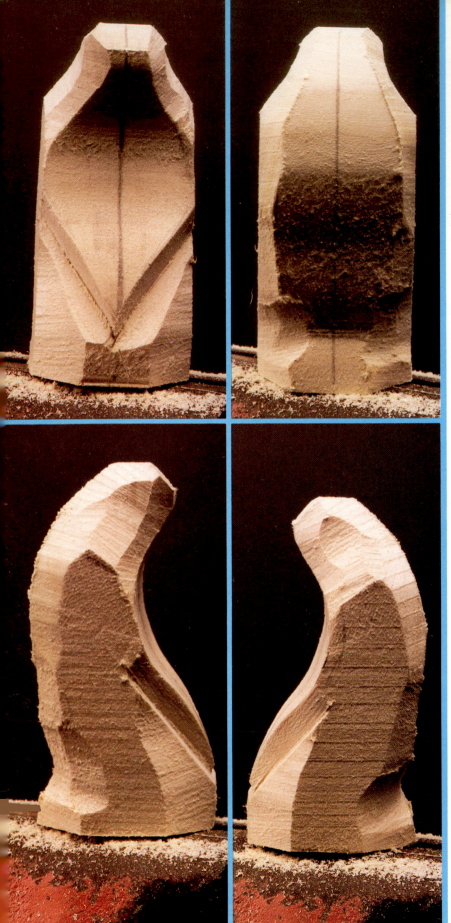

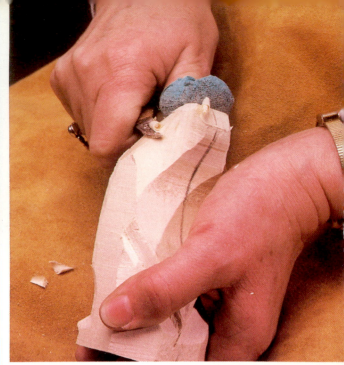

I begin the carving by removing the sawcuts. Be sure to leave the shoulder good and wide for now.

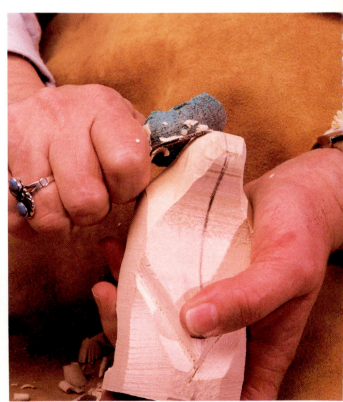

Knock off the corners of the head, leaving the top flat for now.

The results of the work with the coping saw.

16

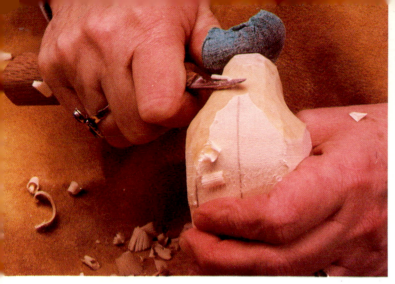

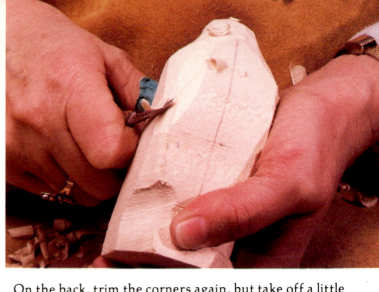

Continue up the back and take off the saw marks from the head without removing very much wood for now. Don't carve the face area at all.

On the back, trim the corners again, but take off a little bit more to start rounding the back.

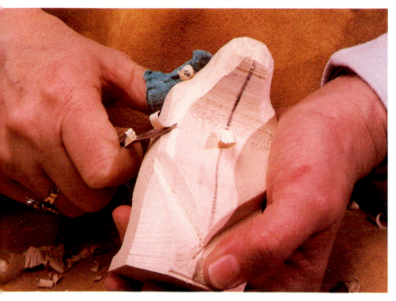

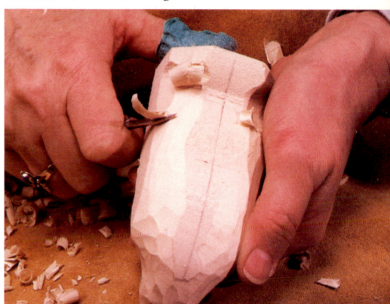

Trim the corners from the front of the arms

When I have the shape I want on the upper back, I continue down behind the legs.

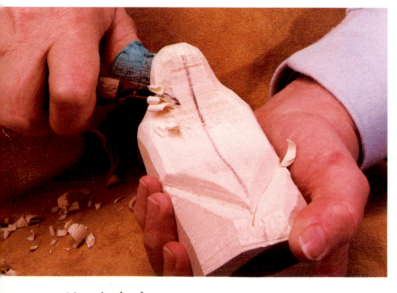

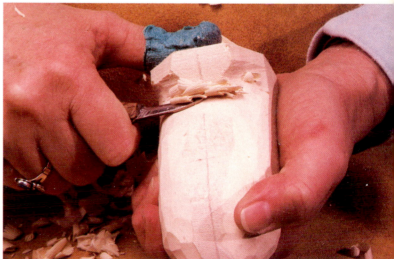

and beside the face.

Trim under the seat...

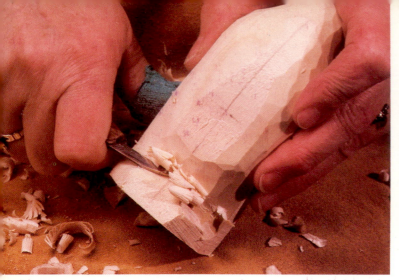

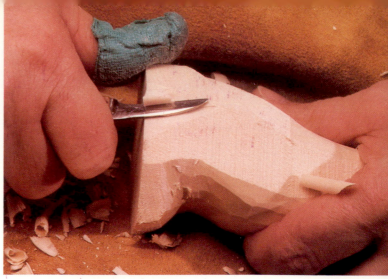

and cut the shavings from the heel.

First, cut off the area marked.

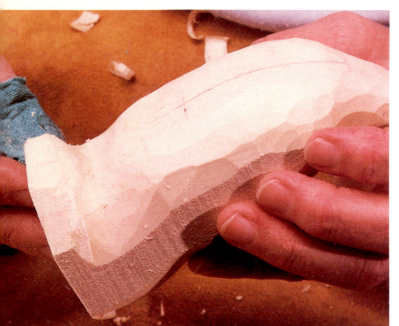

For now this curve is pretty good.

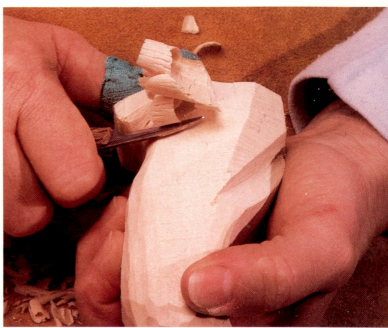

Then remove the material beside the knee with a curved cut. You don't want to carry a curved cut all the way through. Instead make several shaving cuts...

and come back from the other direction and trim them off.

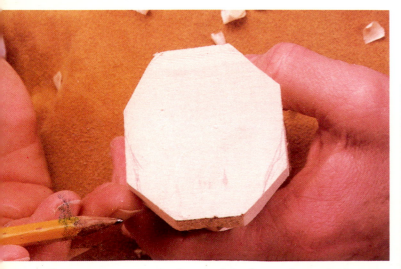

I'm going to trim the front of the base where the knees are, leaving the back flared out.

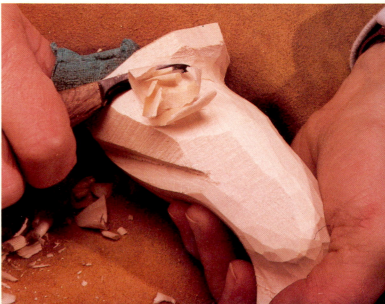

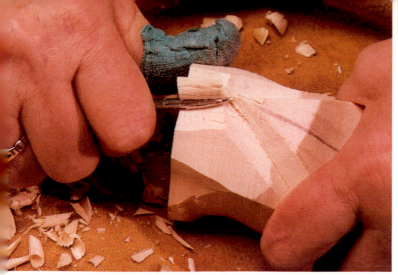

Remove a little of the base below the hands...

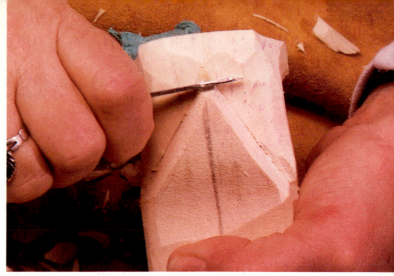

Take a little off at the point of the hand, squaring the end.

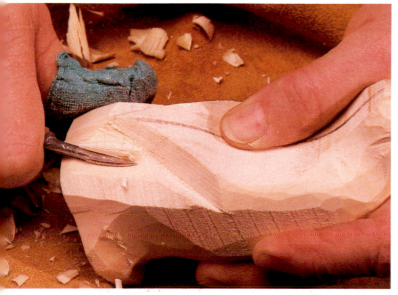

and smooth off the skirt area under the lower arms.

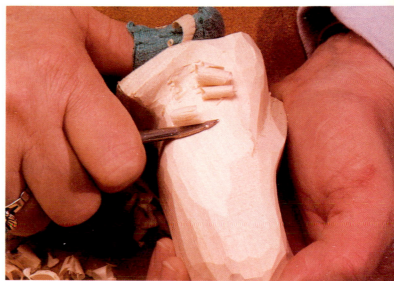

Thin and shape the hip area on each side.

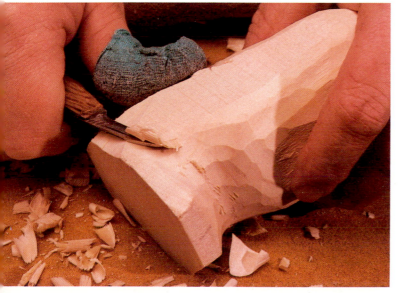

We've created a ridge along the line of the leg that needs to be rounded off.

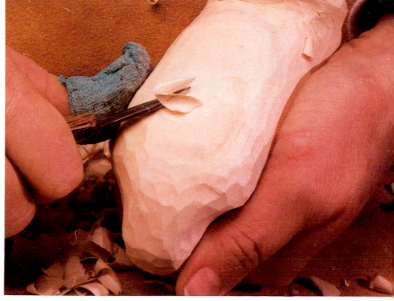

On the back round enough to remove the saw marks.

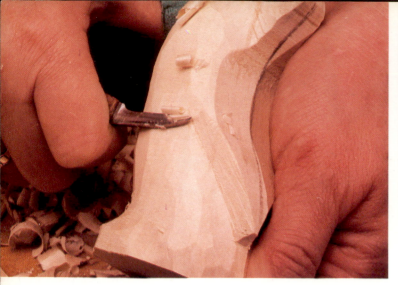

Thin the front of the body a little behind the elbow.

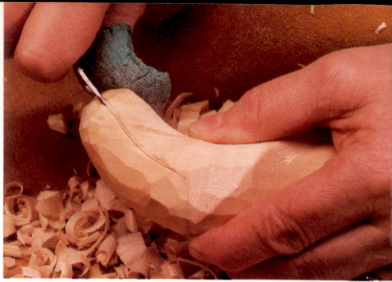

Cut a stop all around the line of the veil.

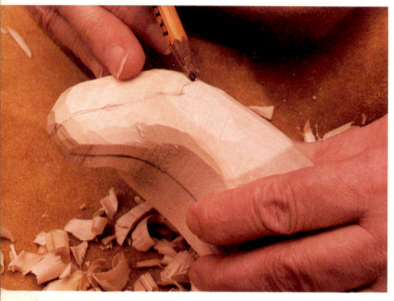

Mark the veil across the front, down to the shoulders...

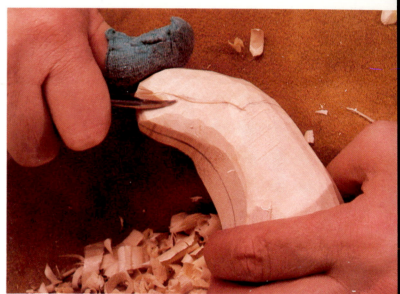

Cut back to the stop from the body, slicing along the line when going with the grain...

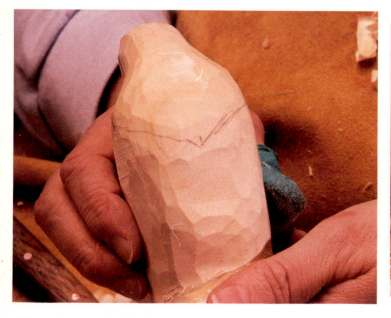

and across the back.

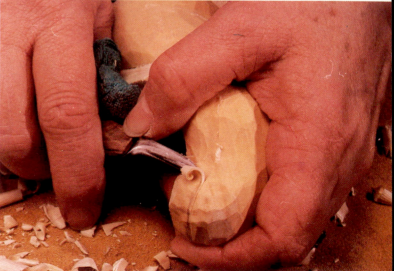

and into it when going across the grain. You can always get to one side more easily than the other.

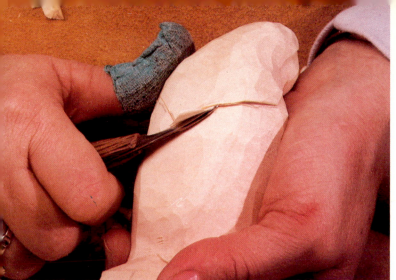

Continue around the back.

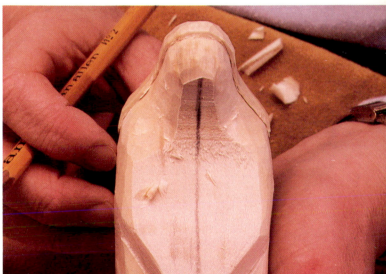

You can now take a little bit more off the corners of the face.

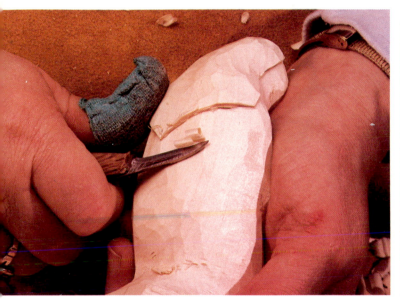

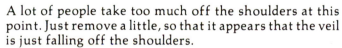

Deepen the stop as you go and trim the back so that it appears to go under the veil.

A lot of people take too much off the shoulders at this point. Just remove a little, so that it appears that the veil is just falling off the shoulders.

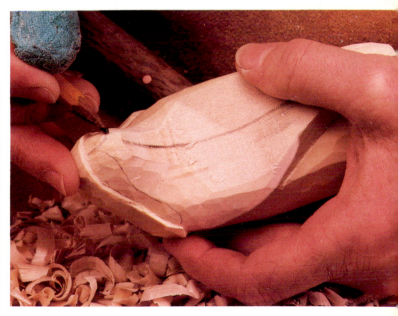

Work the face and head to this shape...

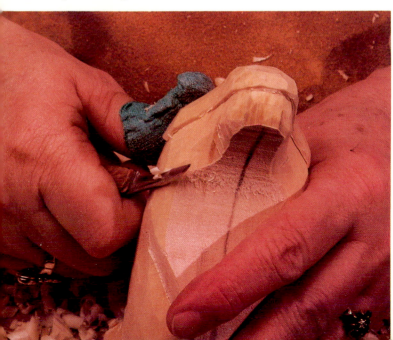

then mark the line of the hair.

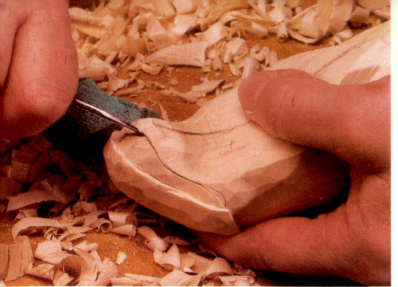

Make a stop cut along the hair line.

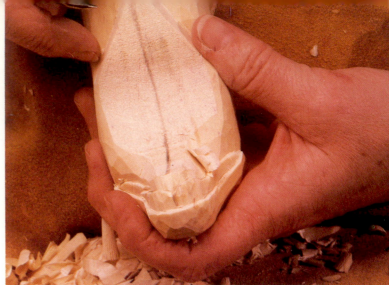

I deepen the hairline stop

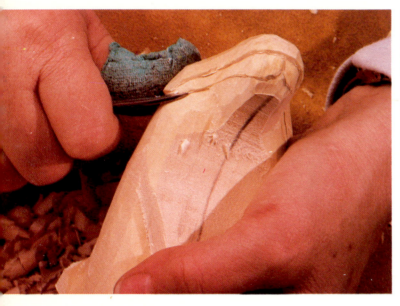

Cut back to it from the shoulders...

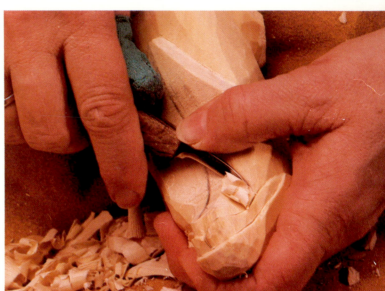

and begin to narrow the face beneath it.

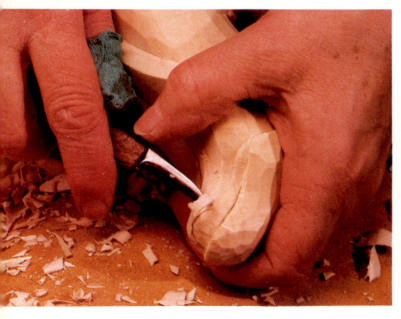

and the face.

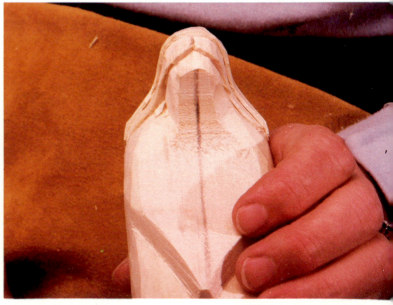

Here is one side done.

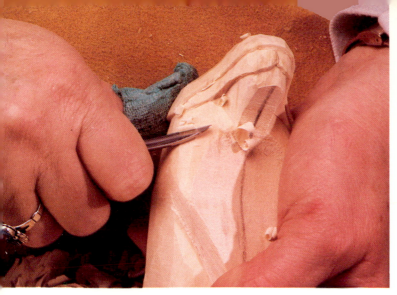

Trim the shoulder a little bit in the front.

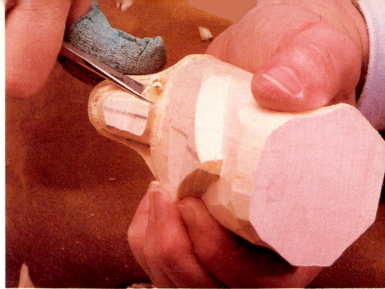

Narrow the face with the skew chisel, down to the neck.

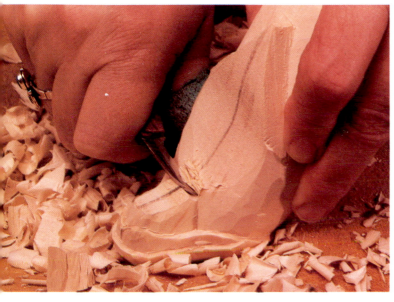

Begin to form the chin by cutting in and then curving toward the chest.

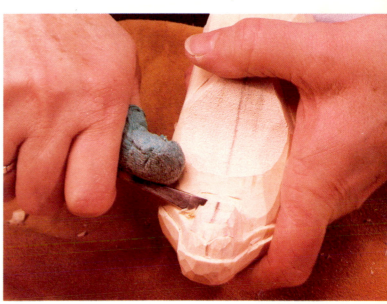

Come back in to the neck from the front of the shoulder.

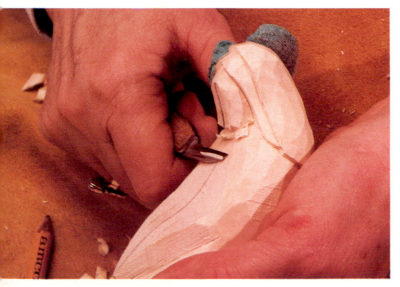

Smooth the chest back to the neck and repeat the process until the chin takes shape.

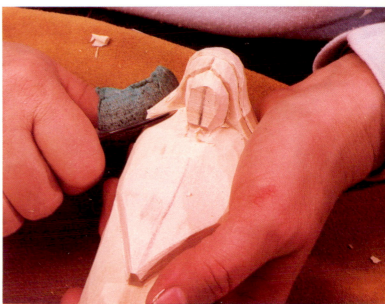

Clean up the area with a knife.

Continue working on the chin and face until you get to this point from the side...

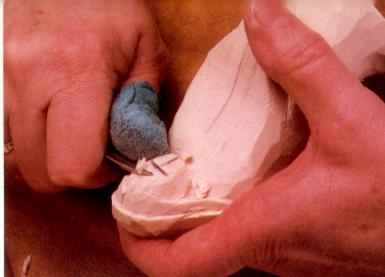

Round the forehead down to the nose line.

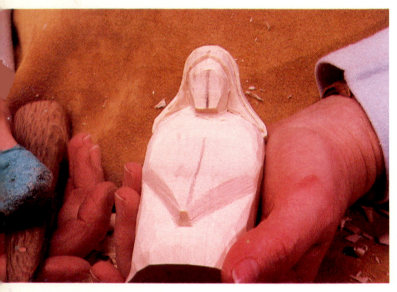

and this point from the front.

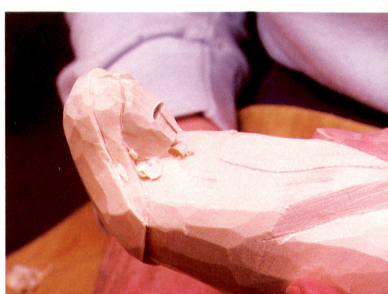

Go to this point.

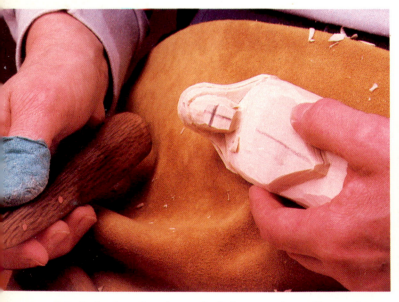

Mark the line for the end of the nose (usually mark it a little long).

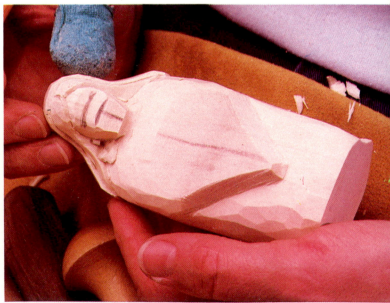

Draw in the eye line and redraw the center line.

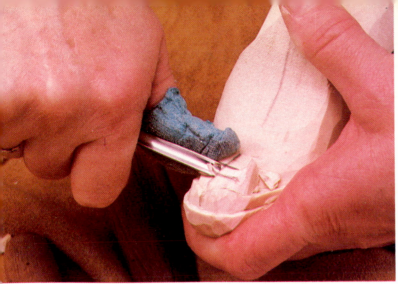

Go across the eye line with a small u-shaped palm gouge.

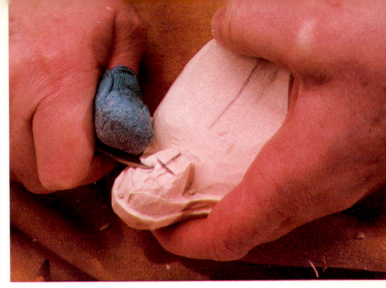

Starting a little bit above the gouge mark for the eye, scoop out the area beside the nose, using a knife.

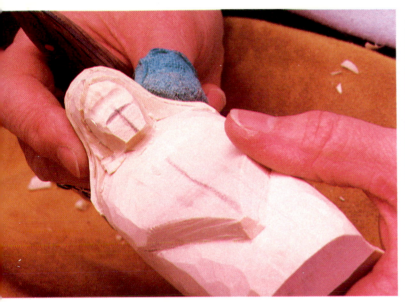

Now you have the indentation for the eyes.

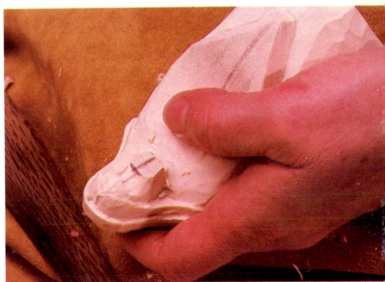

Redraw the lines of the nose.

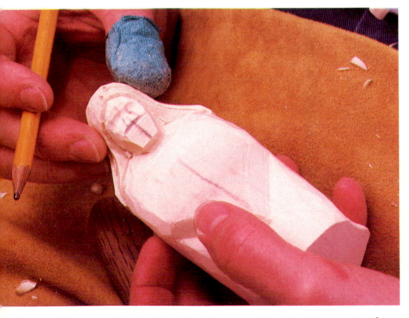

Draw in the outline for the nose, leaving it oversized.

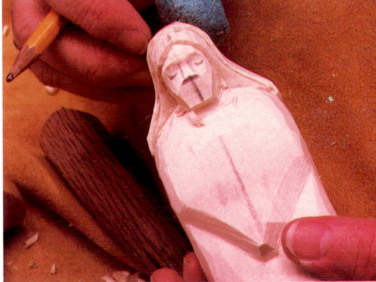

The eyes on these figures are closed, so draw in the line of the eye.

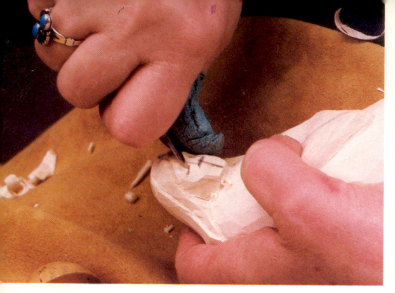

Make a stop cut right on the eye line.

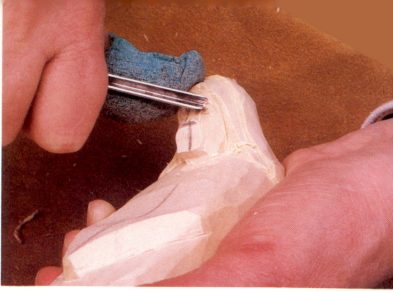

Using a deep u-shaped gouge, follow the line of the eyelid. Start in the middle to avoid chipping the wood.

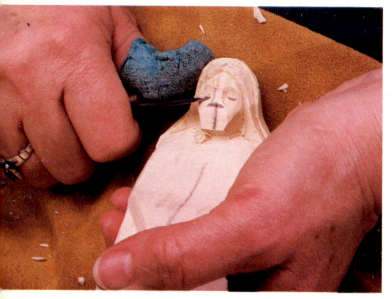

Come up the cheek with your knife and nick out just a little bit under the eye.

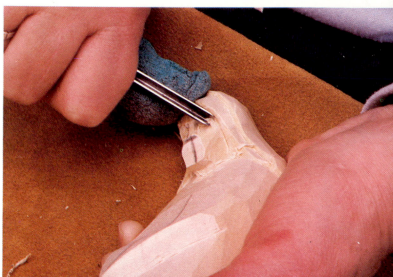

Move to the outside first.

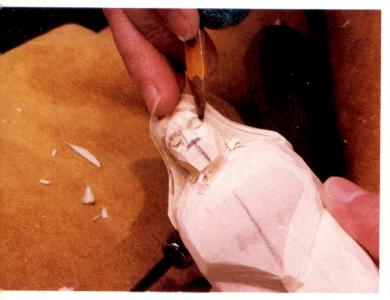

Draw the line of the upper eyelid.

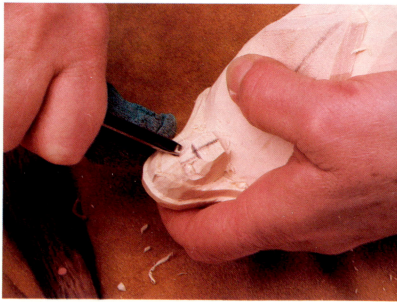

Then, starting in the middle again, move to the inside.

Carry this cut around to the side of the nose.

Come back to the eye cut from the cheek, smoothing a little of the gouge mark beside the nose as you go.

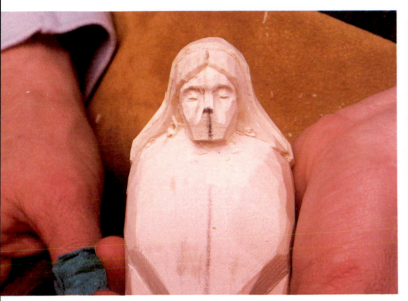

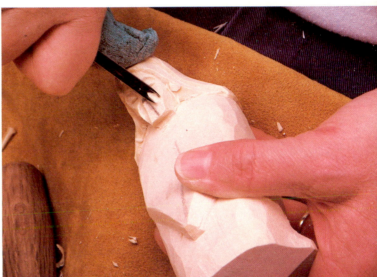

Progress so far.

Using the same gouge as before, continue the line beside the nose down to the chin...

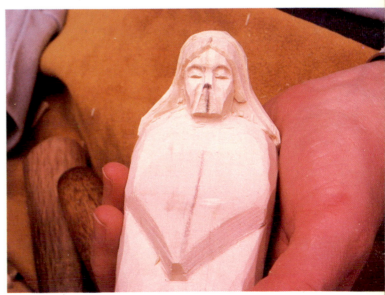

With you knife, go over the eye cut again, going a little bit deeper.

to get this result.

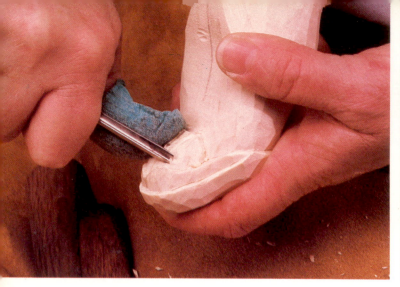

Bring the gouge from the corner of the eye into the temple to give more shape to the face.

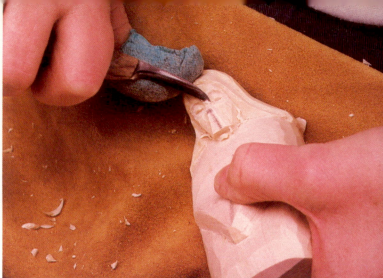

Use the knife to shape the bridge of the nose.

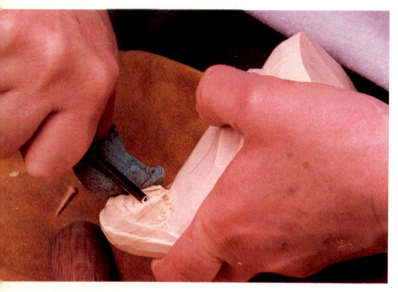

Use the gouge to remove wood from the lower cheek.

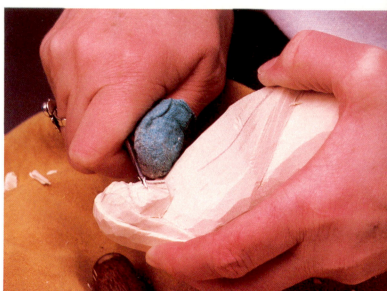

With a slightly slanted cut, go into the bottom of the nose. Don't trim the lip area yet.

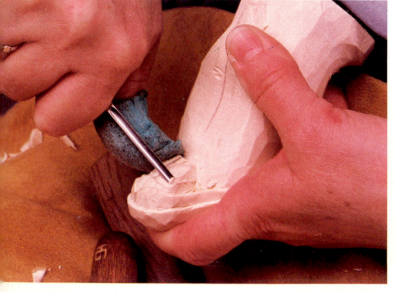

With a gouge go across the upper cheek under the eye, creating the recessed look that is natural.

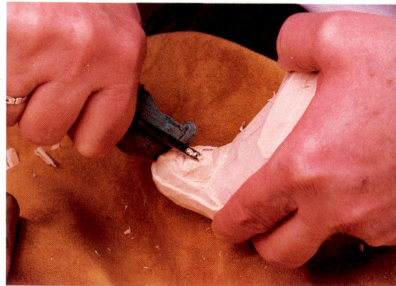

Go back with the gouge and deepen the cheek line.

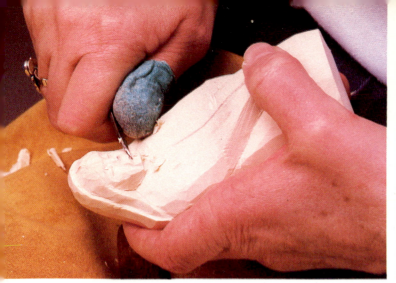

Cut in below the mouth...

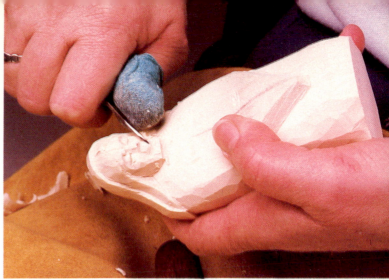

Smooth the area beneath the nose that will become the mouth.

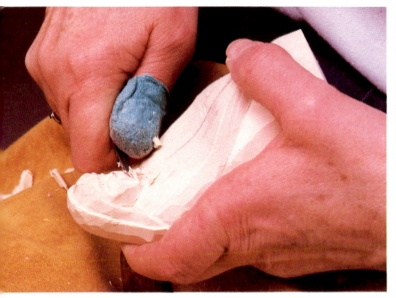

and down toward the chin.

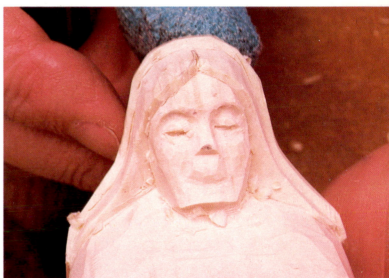

The face is taking shape.

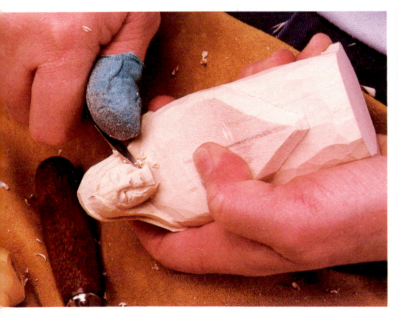

Now smooth the gouge marks on the cheeks.

With the gouge go across the chin under the mouth and take away a little more.

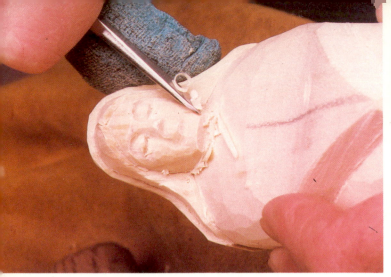

Begin to shape the jaw and chin using the skew.

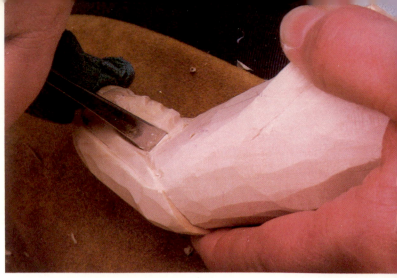

Emphasize the jaw line using the skew.

Do one side then the other to help keep things symmetrical.

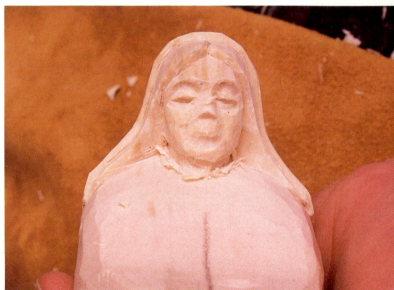

The neck is beginning to take shape.

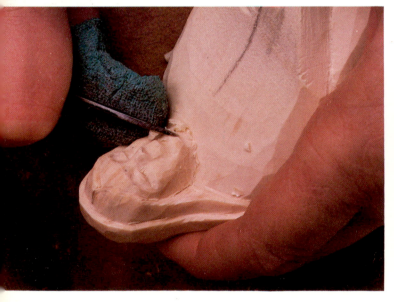

Use the knife to soften the line of the chin.

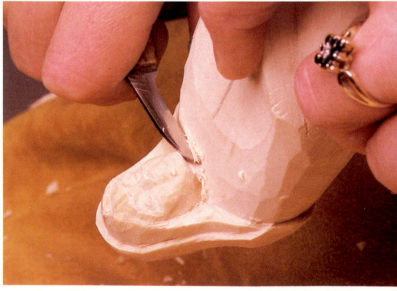

Go in under the chin with the knife, and roll it out to shape the neck.

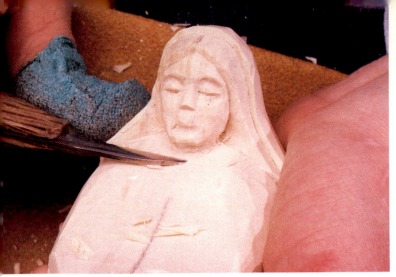
Clean up the cuts by trimming from the chest.

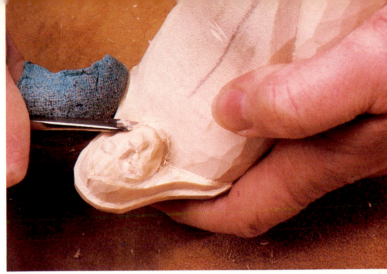
Narrow the chin line until it seems right.

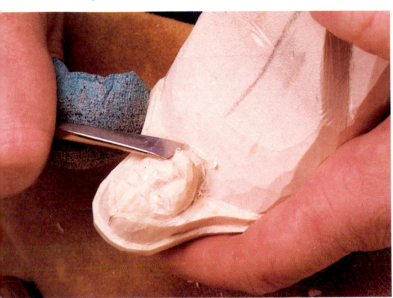
The chin is wider so I will shape it a little more with the skew. I use the skew a lot because with its beveled blade it gets in tight spots.

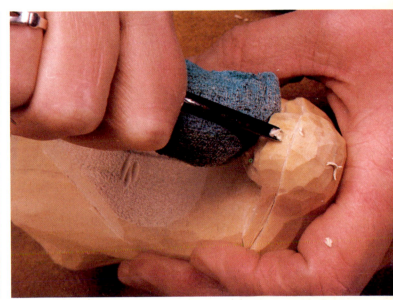
Use a small u-shaped gouge to make the part in the hair.

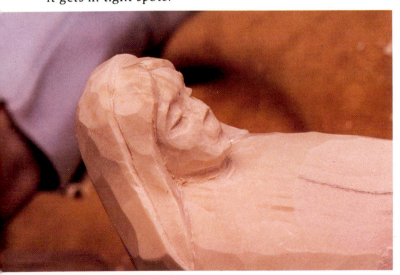
You want this mound under the nose for the mouth. Otherwise the mouth will be flat.

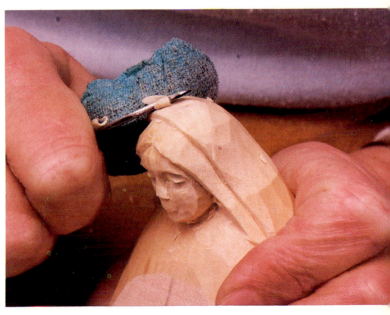
Take a little more off the veil to thin it.

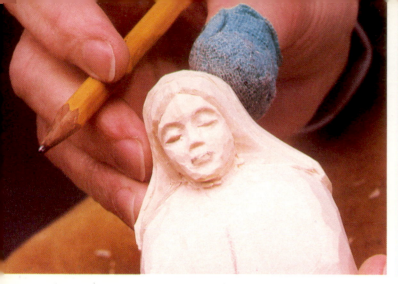

Draw the line of the mouth, bringing it down a little at the corners.

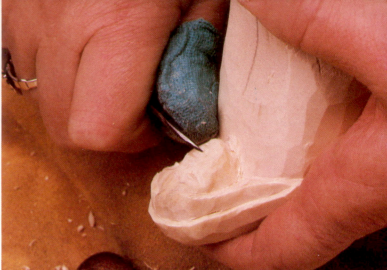

With a knife shape the lips, first the top...

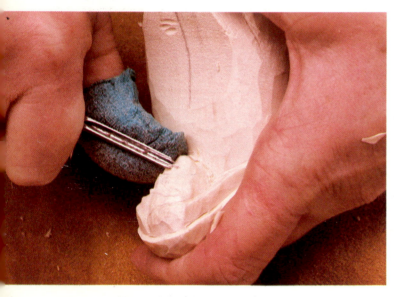

Starting in the middle of the mouth and working out to the sides, follow the line with a small gouge. Don't go deep.

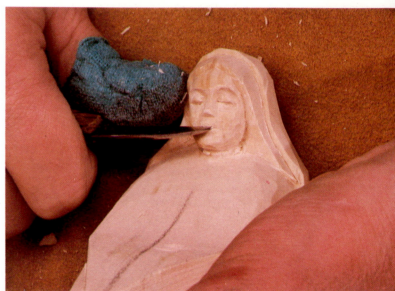

then the bottom.

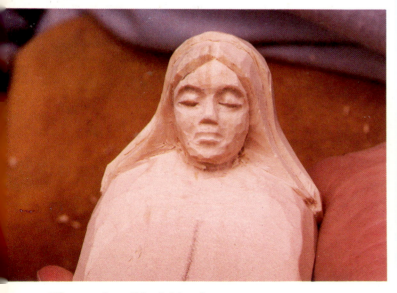

The result will look like this.

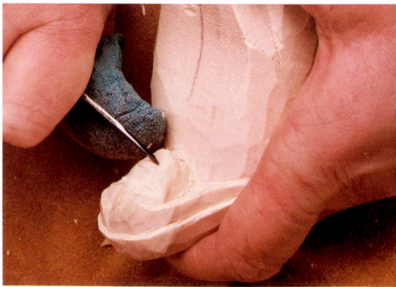

Press the tip of the knife into the corner of the mouth defining it more clearly.

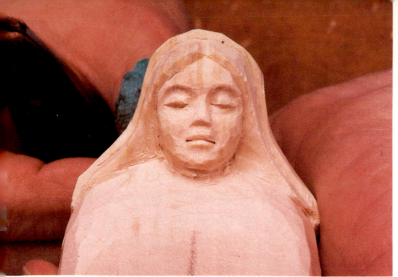

The result.

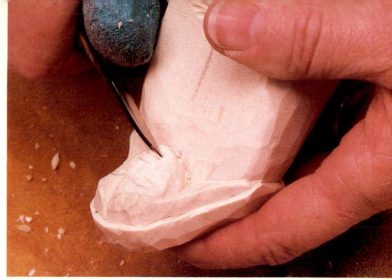

With the point of the knife almost to the corner of the mouth roll out a curl cut toward the chin. This will bring the lower lip under the upper.

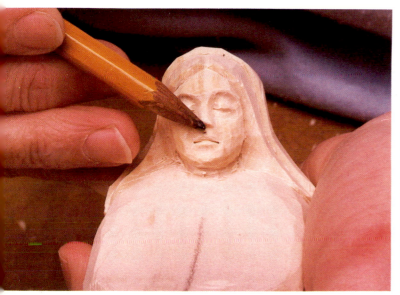

Mark the "angel's thumbprint" under the nose.

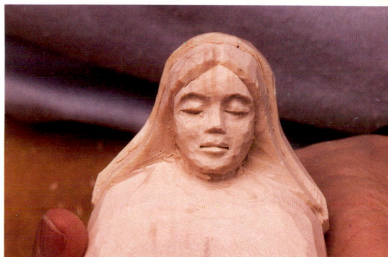

The mouth and face so far.

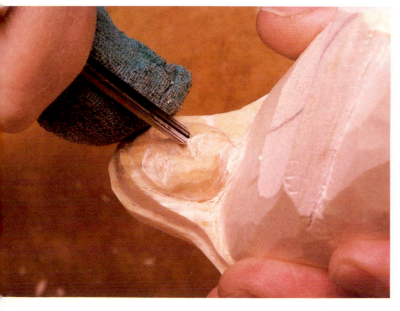

Come down from the nose to the lip with a small gouge.

Round off the eyelid to make it seem more natural.

Draw in the opening of the cape.

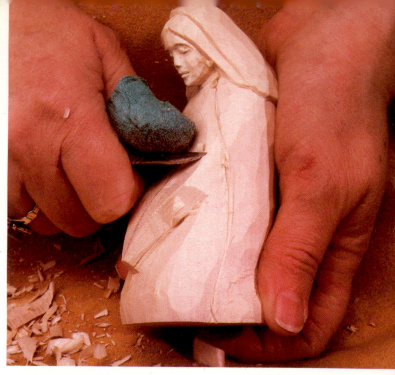

Shape the body and arms so they appear to be coming from under the cape.

Make a stop cut along the opening of the cape.

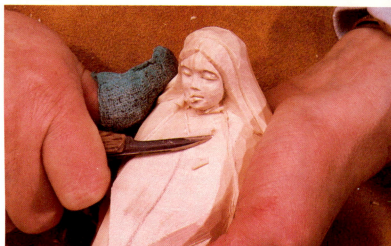

Smooth the area of the upper chest.

In the corner where the elbow meets the cape, cut a stop along the arm....

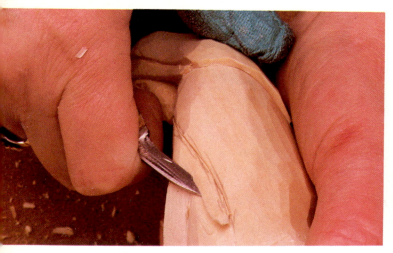

Cut back to it from the dress.

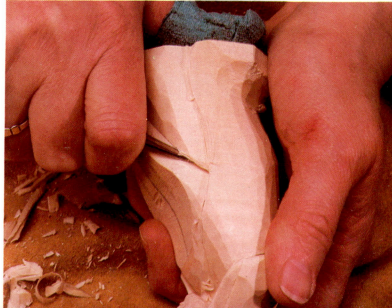

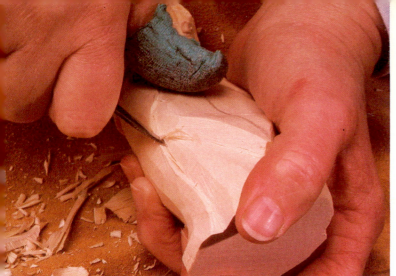

and one along the cape.

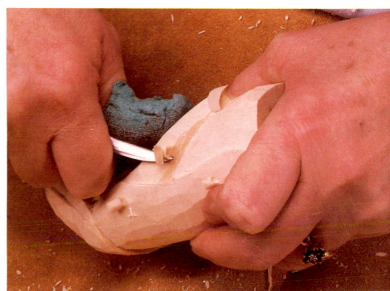

Trim the skirt.

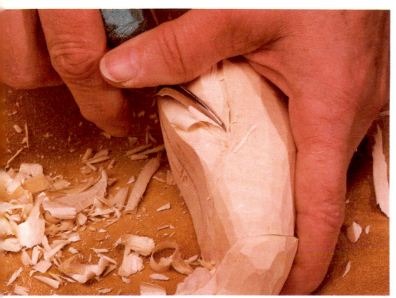

Clean out between them.

Clean it out to this depth.

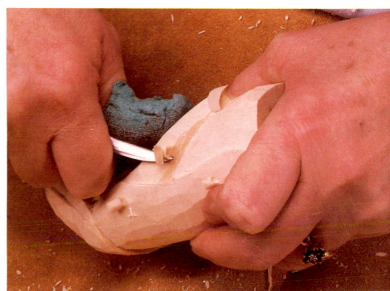

Straighten and smooth the arms so the cape appears to overlap them.

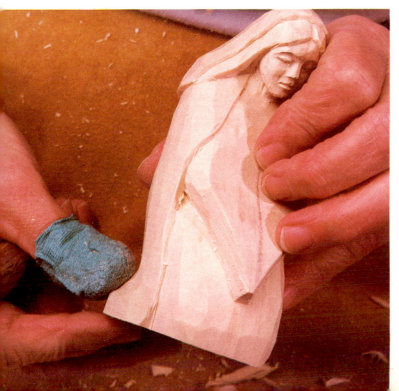

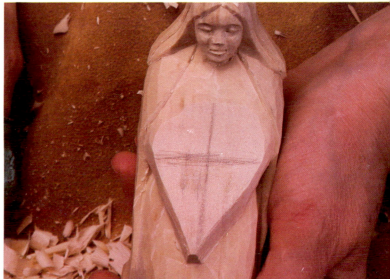

The bend in the arms follows this horizontal line.

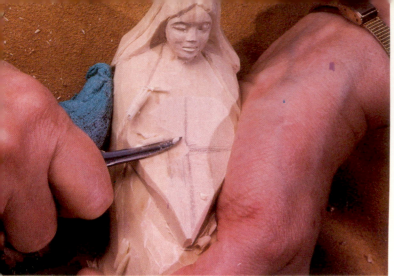

Starting at the corners and going across, trim a little dip along this line.

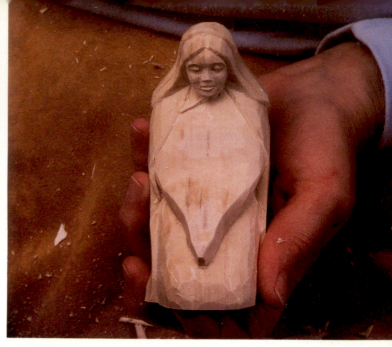

The result.

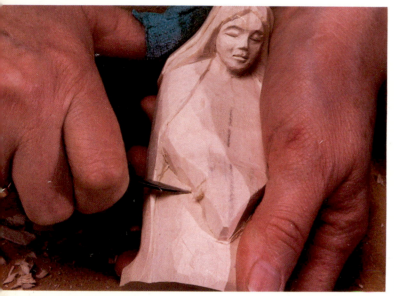

Make a stop cut between the arms and the body...

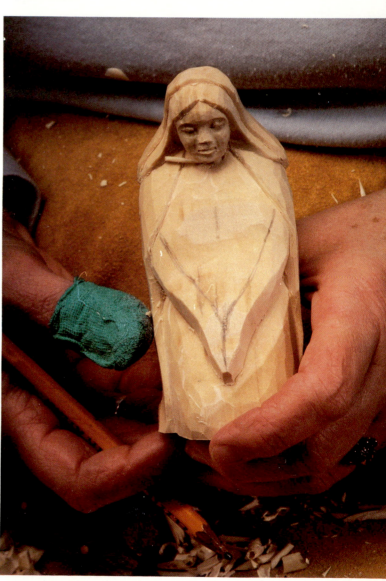

Draw in the line of the arms and palms.

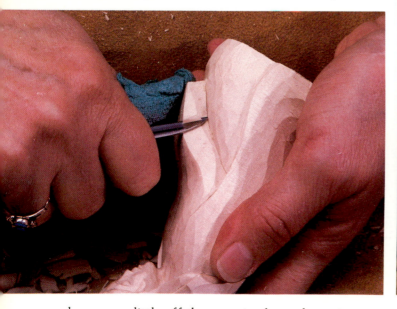

and remove a little off the arms to shape the wrists.

Make a stop cut into the point, but not into the palm.

With a small gouge scoop out the area from the v of the arms to the waist.

Cut back to the stop from the body.

Deepen the stop cut up to the line of the waist.

Start at the V and let the bite of the gouge gradually taper out as it reaches the waist. We want this area to be at the same level as the knees.

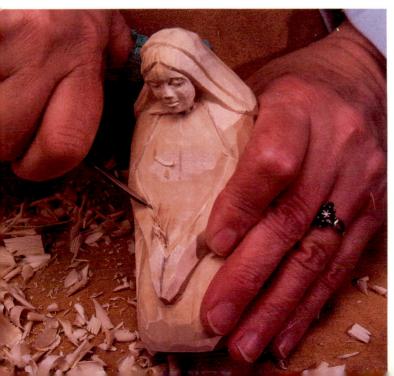

When you reach the bottom of the stop cut, make it again and switch to an even smaller gouge to continue the removal of material.

37

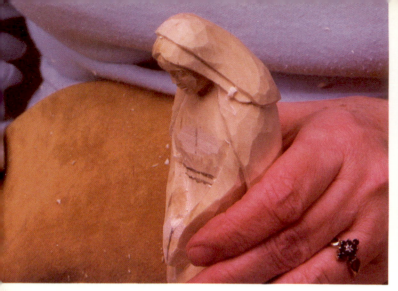

When you get to this depth, draw in the belt at the waist line.

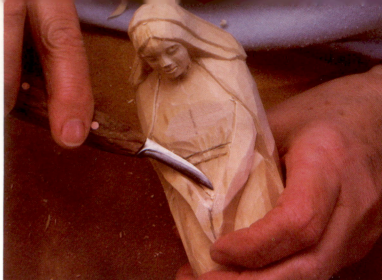

Be careful here. You don't have to go very much deeper, but you do need to bring this area below the belt.

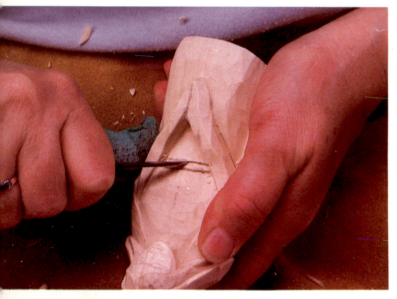

Make a stop cut on both lines of the belt.

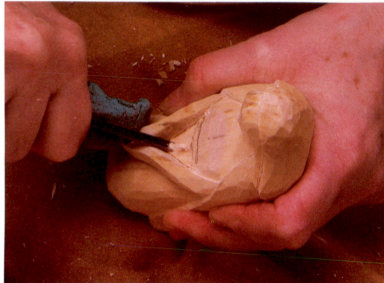

With a small gouge start at the bottom and work toward the belt. You will probably have to recut the stop under the belt two or three times to make it deep enough.

From the top line of the belt cut a stop along the insides of the arms.

Redo the stops along the arms below the belt.

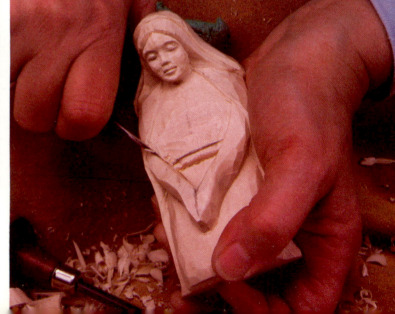

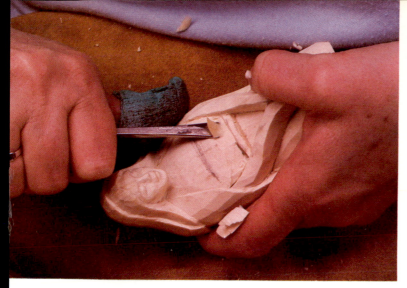

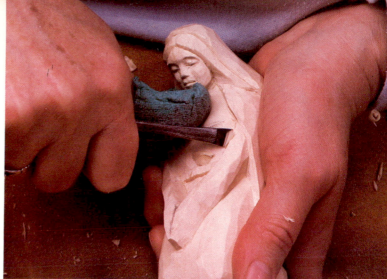

Mark the breast line, where you will not want to remove anything. With a skew trim the bodice down to the belt. Again, you may have to renew the stop cut two or three times to get the proper depth.

With the skew begin to round the chest toward the arm...

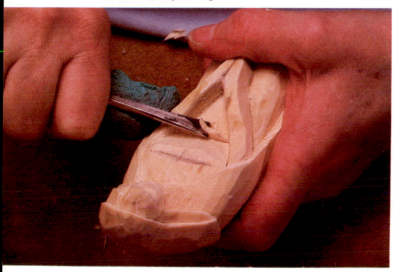

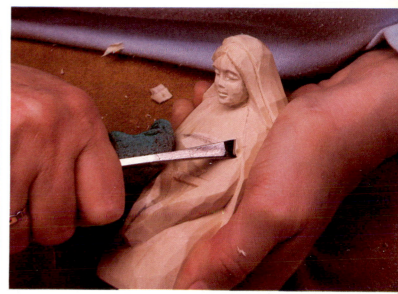

This of course makes the belt way too thick. Working from the center out, trim the belt with the skew.

and toward the cape. Repeat until it is rounded the way you want it.

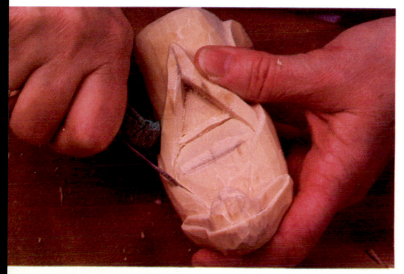

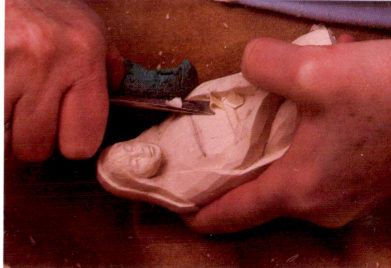

The chest area needs to rounded off. Begin by making a stop cut along the line of the cape to the arm.

Remove some more down to the belt.

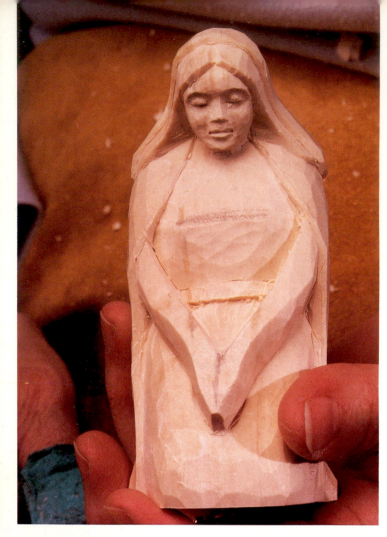

Keep removing above and below the belt until you get to about this depth.

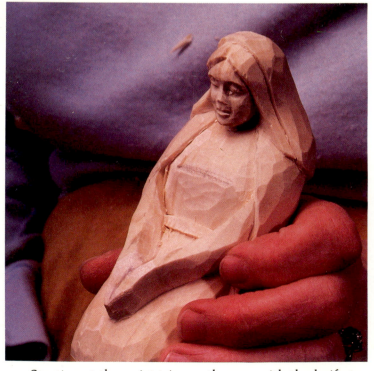

Starting at the wrist trim up the arm with the knife to thin it.

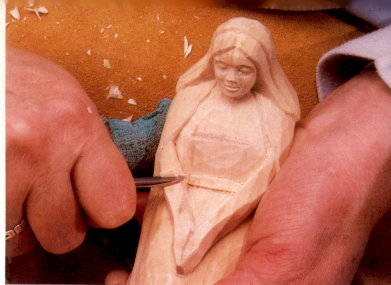

When you get to the belt line, dip in a little more for the bend in the arm.

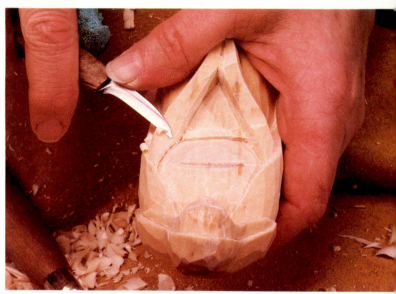

When you approach the cape, start rounding off the arm.

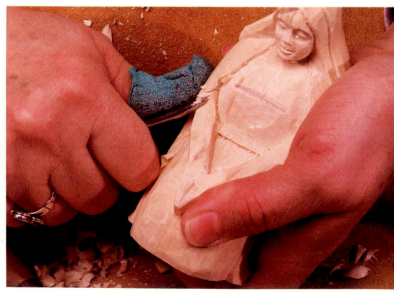

Shape the arms.

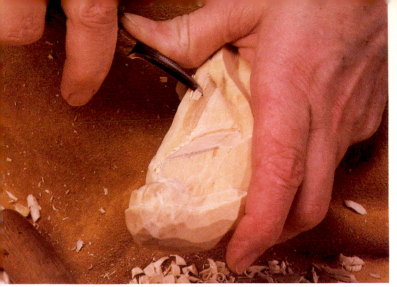

Thin the forearm from the elbow to the wrist.

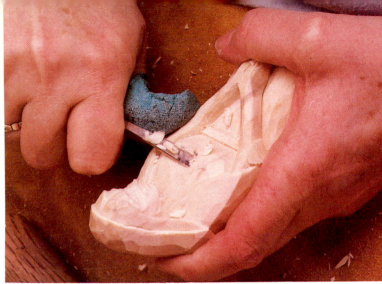

and bustline by taking away just a little.

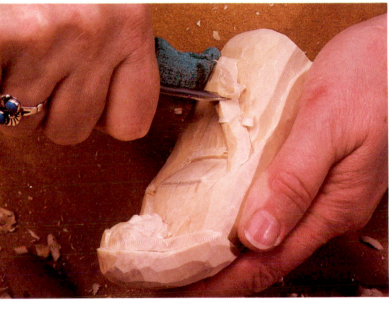

Go back and clean up the work as you continue.

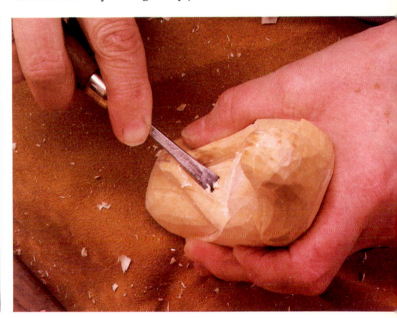

Use the skew in the lap to smooth up the gouge marks.

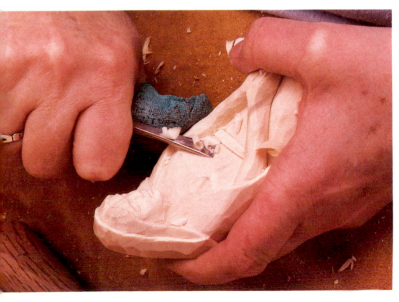

Shape the bodice of the dress...

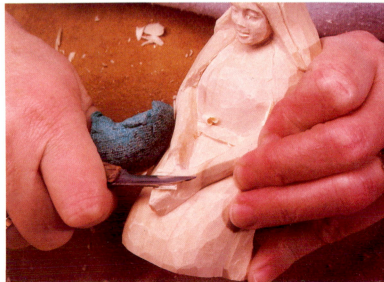

Clean the top part of the hand.

Round off the edges.

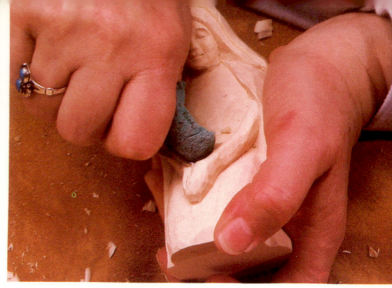

Then turn the piece and trim out a little between the hands.

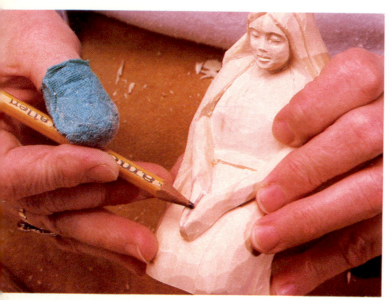

Remark the middle line of the hands.

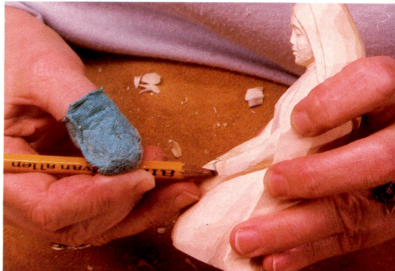

Draw the sleeve line at the wrist.

Make a stop cut down the center line.

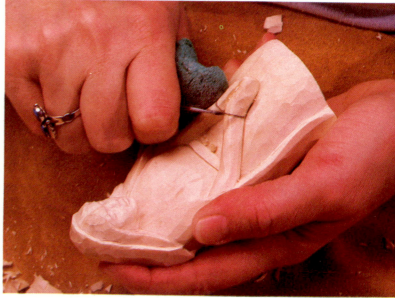

Cut a stop on the sleeve line.

Trim back to it from the hand.

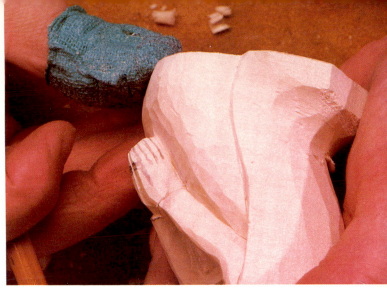

Continue to mark the fingers, making a center mark first and one on each side.

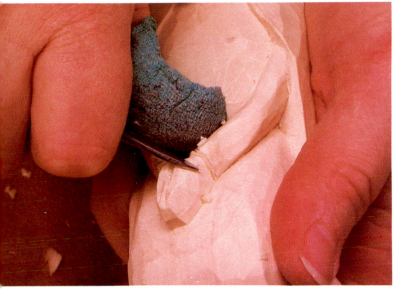

Shape the hand back toward the wrist.

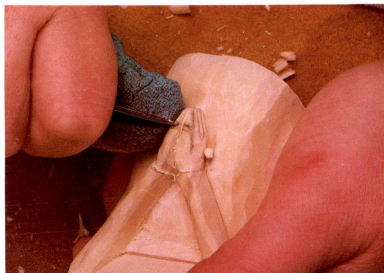

Make a light stop cut at the tip of the thumbs.

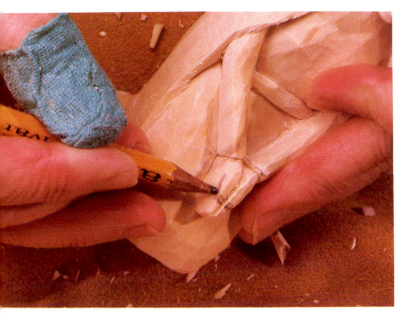

Mark the thumbs.

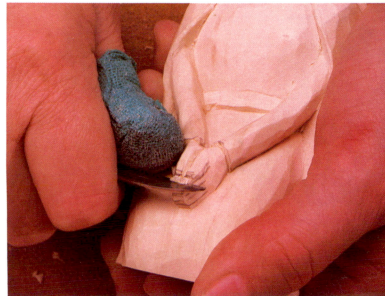

Cut back to the thumbs from the end of the hands.

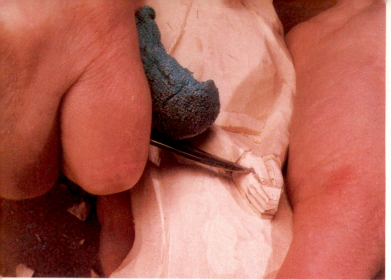

Make a shallow stop cut in the thumb line.

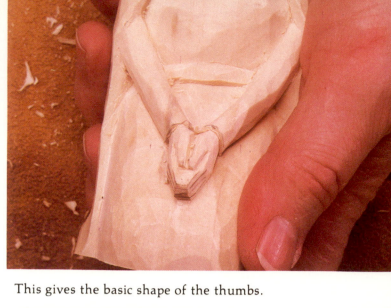

This gives the basic shape of the thumbs.

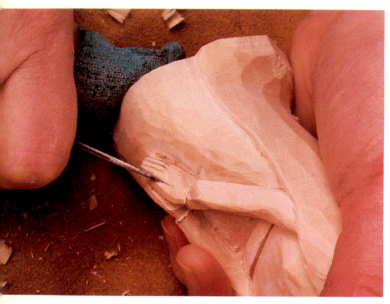

Turn the piece and cut a sliver out of the line.

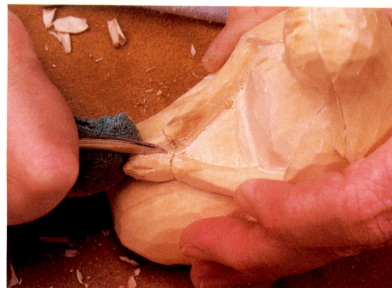

Clean out a little between the thumbs.

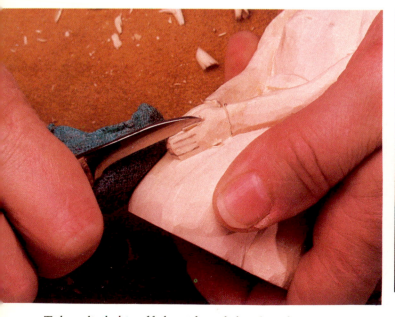

Take a little bit off the sides of the thumbs.

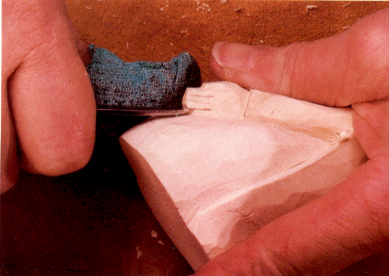

With the fingers do as you did with the thumbs. Make a shallow stop cut.

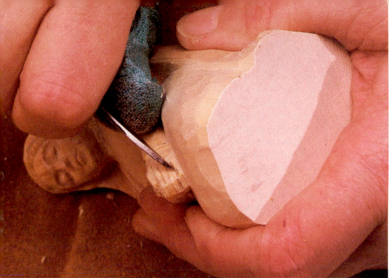

Turn the piece and take out a thin sliver.

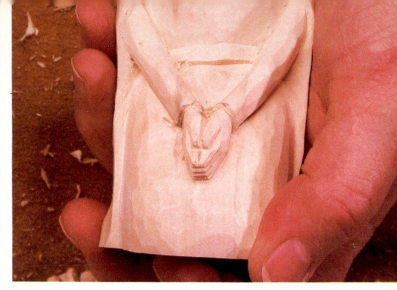

Mark the separation between the hands.

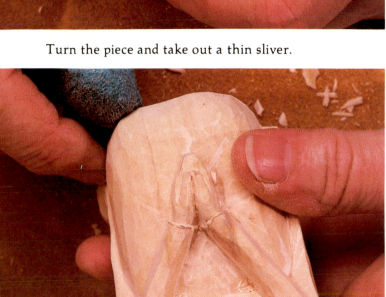

The hands are still a little heavy looking, so I'll thin them down.

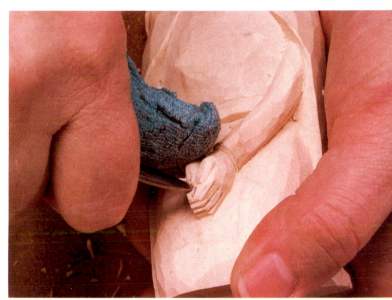

Make a v-cut first going one way...

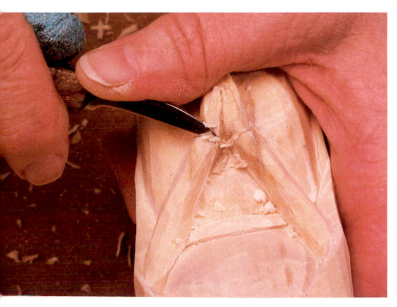

A lot of this can be fixed by simply slimming the wrist.

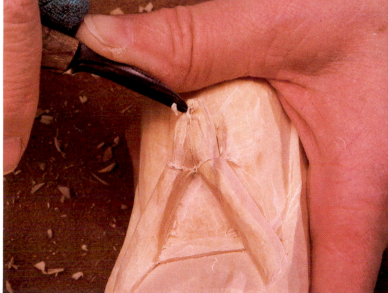

then the other.

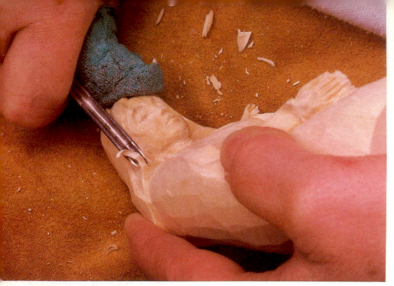

To soften the hair line use a u-shaped gouge and carve the sharp edge.

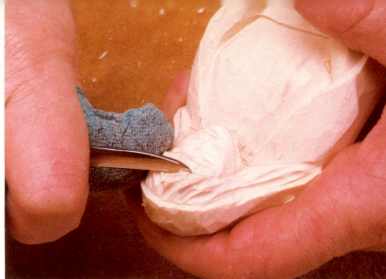

Keep your eye open for places you can clean up and sharpen, like the forehead and hairline.

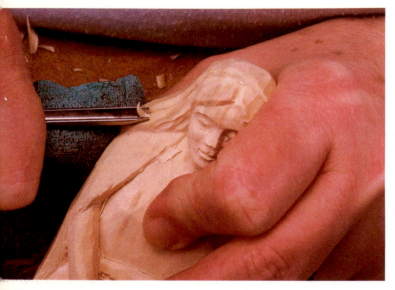

Then, with the same tool, add hair lines throughout.

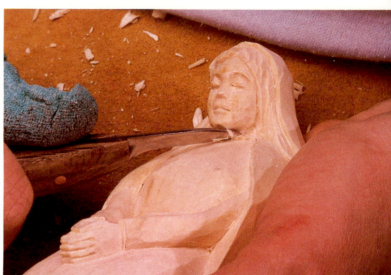

One problem area is under the neck. If you aren't careful it will look like you're slicing her throat! Go gently with a rolling motion carrying your knife up the neck instead of into it.

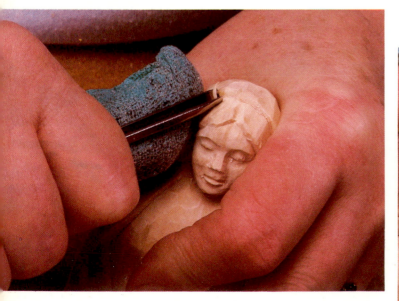

As you're doing this, watch the grain, kind of curve the hair, and don't create straight lines.

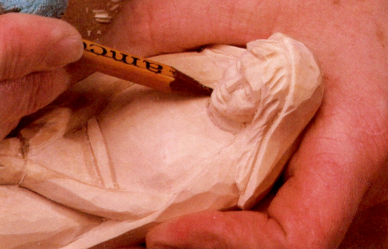

Draw in the neckline of the dress.

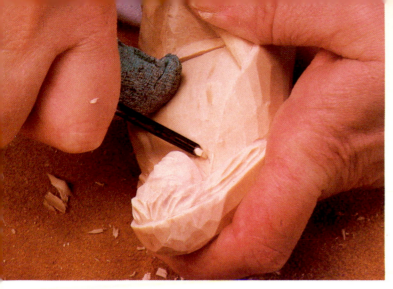

Use a small u-shaped gouge to follow the line, starting in the middle and going out.

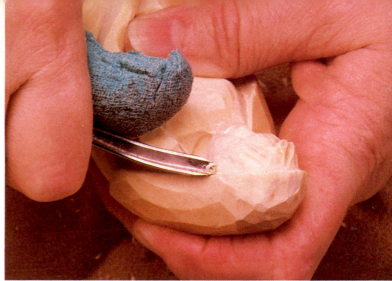

A small v-tool is handy for cleaning out places like around her veil.

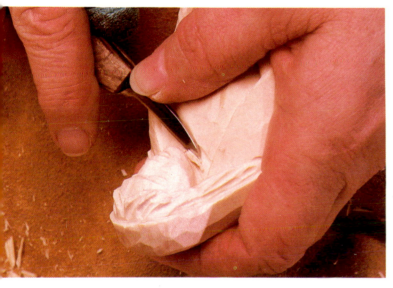

From this line use a knife to trim just a little off the collar area.

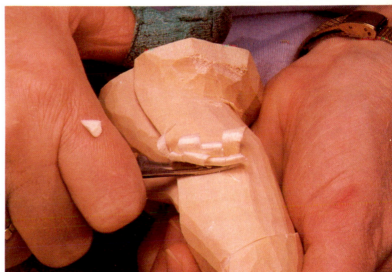

The cape needs to be carved to flow with the shape the arm. Carve one way...

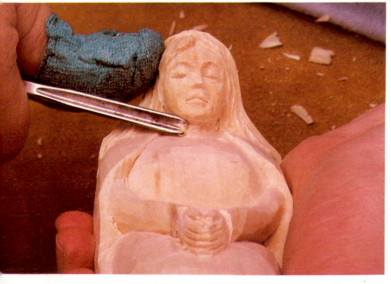

If you're very careful you can use a deep u-shaped gouge that fits under her chin to smooth out the neck.

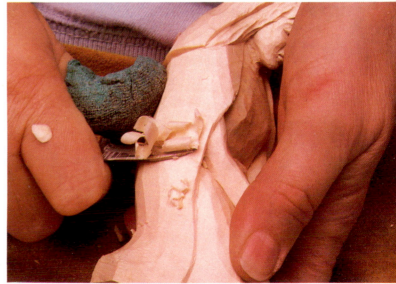

Then turn the figure and clean it up.

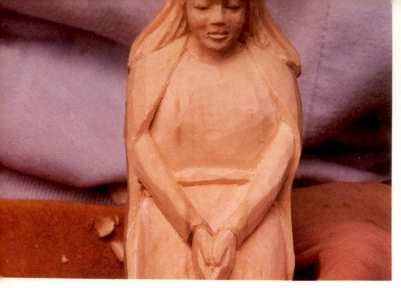

This just pulls it in a little, giving it a more realistic look.

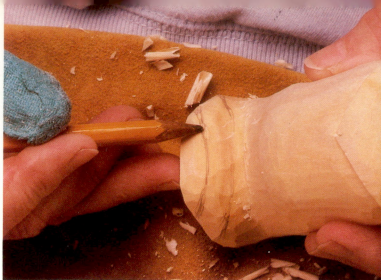

Mark a couple of folds across the base.

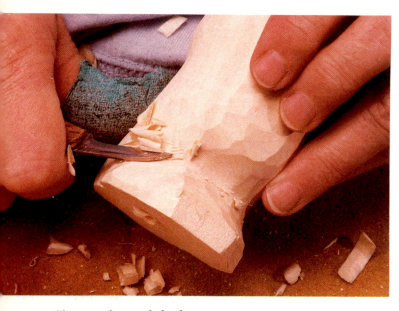

Clean and round the base.

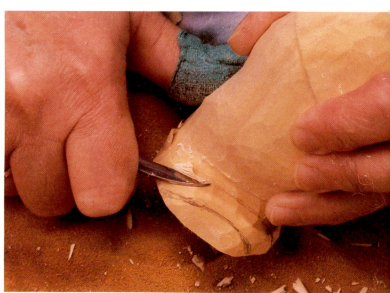

With a knife cut toward the fold line and roll your knife up. With the direction of the grain going up and down the piece, if you cut the other direction it will break off the wood.

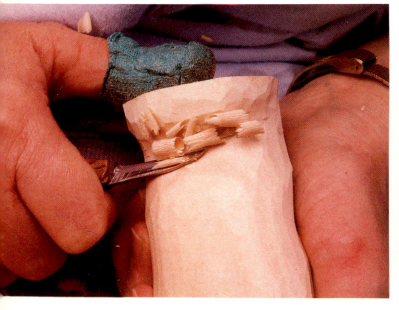

Deepen the area behind the knees.

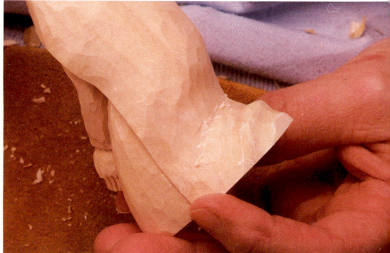

The finished folds.

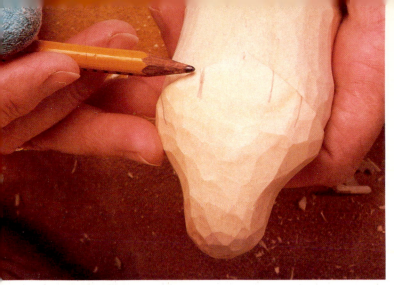

Mark four folds in the back of the veil.

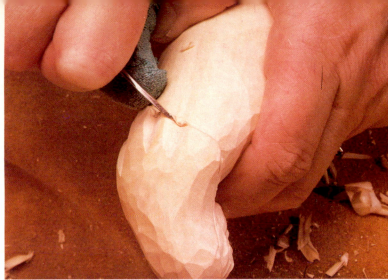

Cut a stop in the line...

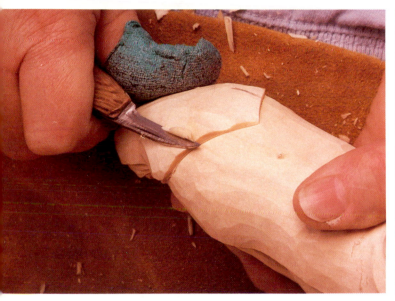

With the knife, making rolling shallow cuts through the lines you have drawn.

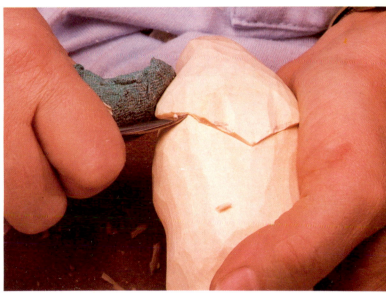

and cut back to it.

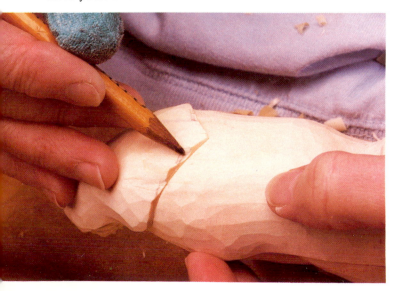

At the end of each of these fold cuts, draw a little scallop in the line of the veil.

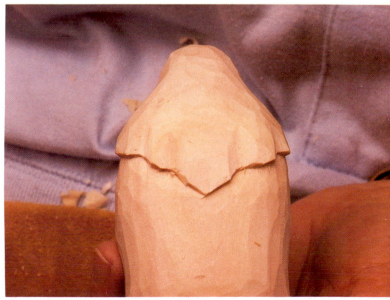

This is the effect you are after.

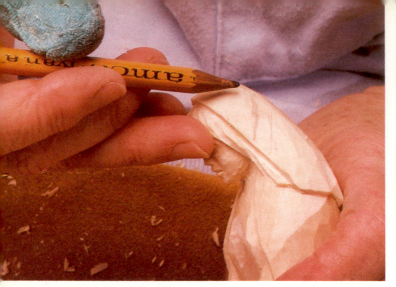

On each side of the veil you want a couple wrinkles.

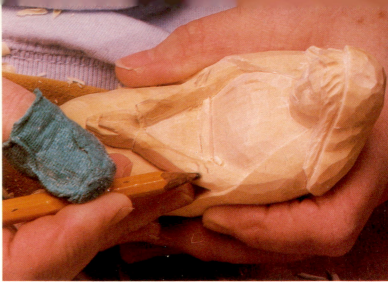

Also add some wrinkles on the crook of the arm.

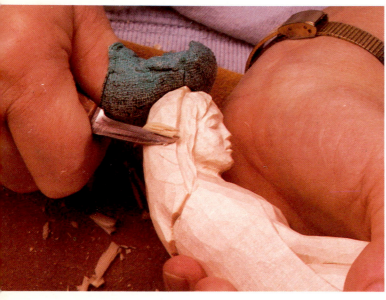

Again make a rolling slice with your knife through the wrinkle lines...

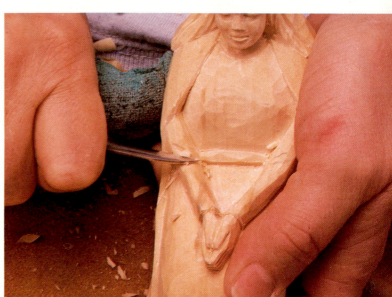

Again use a rolling knife cut.

to get this look. These details give the piece a softer, more realistic appearance.

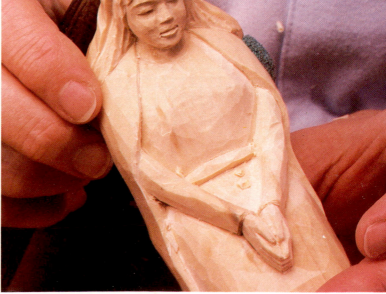

The result.

I begin my sanding with a 150 grit cloth-backed emery paper. I roll it in a tube because it is easier for me to hold and allows me to put more pressure on my sanding.

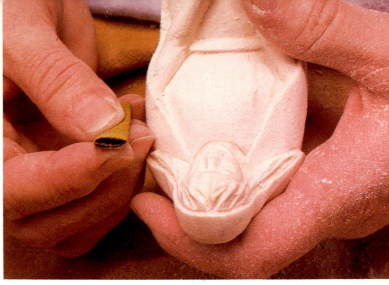

When moving to the face, use a much smaller piece of paper.

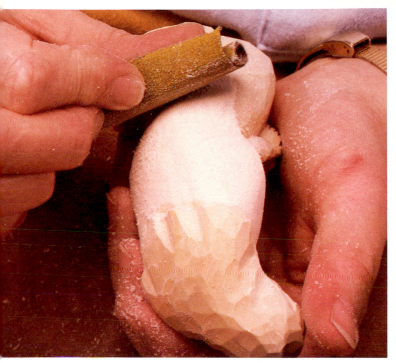

Go all over the piece removing knife marks until the piece is smooth. Don't sand so much that you change the shape of the piece.

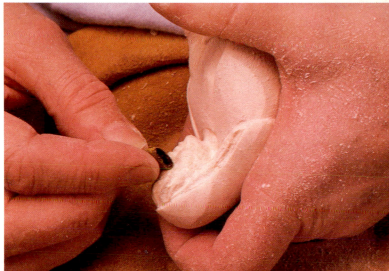

This allows you to get into the smaller places without sanding away detail.

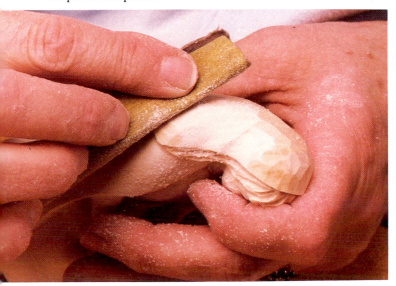

Continue over the whole piece.

When I switch to the finer, 220 grit, sandpaper, I wrap it around a needle file to get at the small details on the face...

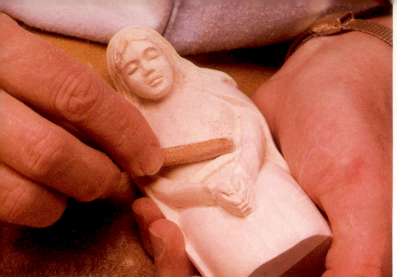

and body.

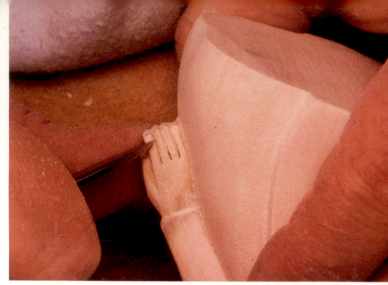

To form the finger nails, make a stop cut at the cuticles...

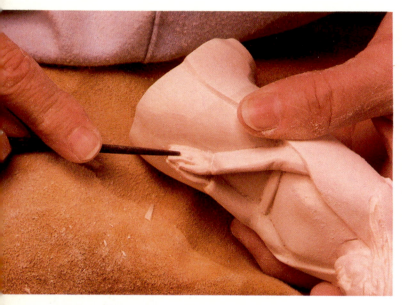

I use a little needle file to smooth the areas between the fingers.

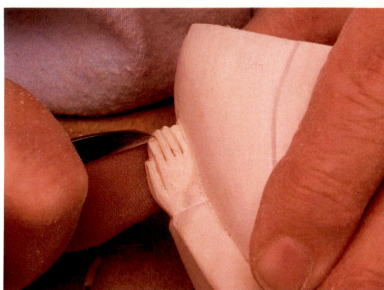

and cut back to it lightly from the tip.

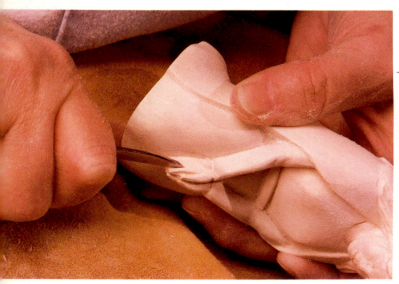

You can take the point of the knife to deepen the definition of the fingers.

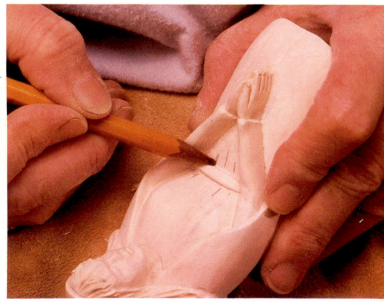

Mark some gathers on the dress along the belt line.

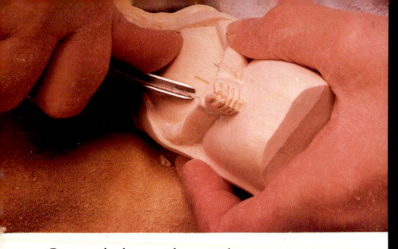

Go over the lines with a v-tool.

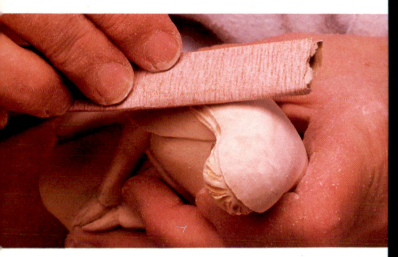

You can go to 320 grit paper for a final sanding. The finer the paper the smoother the work.

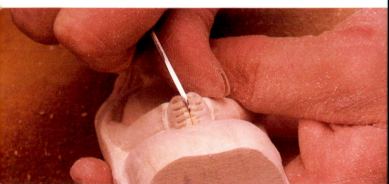

As you are sanding you may find little spots you've missed, like the line between the two hands at the fingertips. I simply press my blade into the wood to separate them.

Finally I sign the piece on the bottom, using a v-tool.

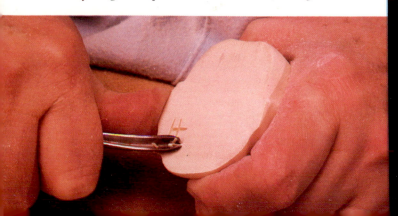

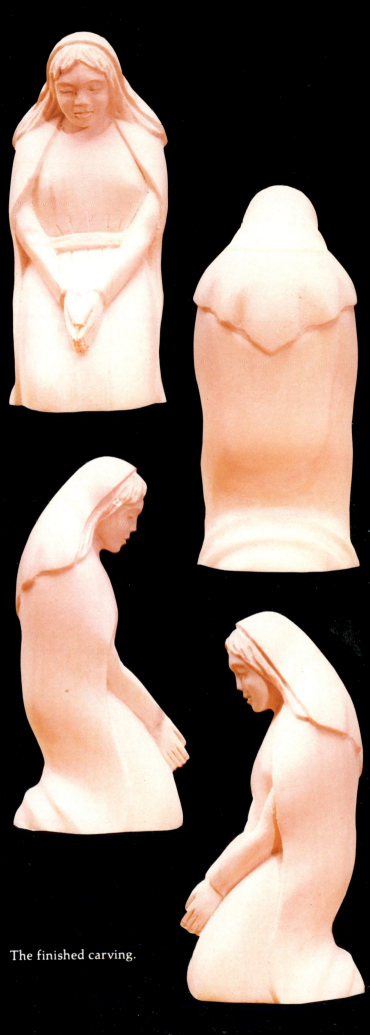

The finished carving.

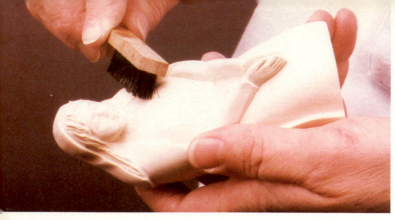

Before applying the finish, brush away all the dust from the sanding.

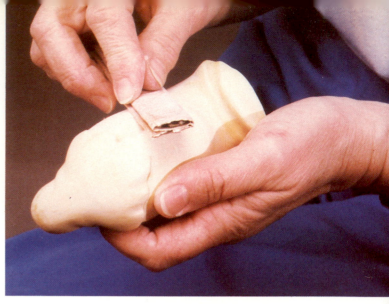

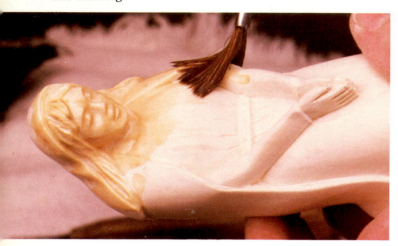

I always use Deft Semi-Gloss finish. This is a fast drying finish, which is an important consideration when doing several coats on several pieces. Apply a thin, even coat over the whole piece.

The first coat applied. Notice how the streaks in the wood are highlighted by the finish.

The first coat seals the wood and raises the grain a little, giving it a rough feel. I go over it again with a piece of 320 grit sand paper that I have already used, before applying the second coat.

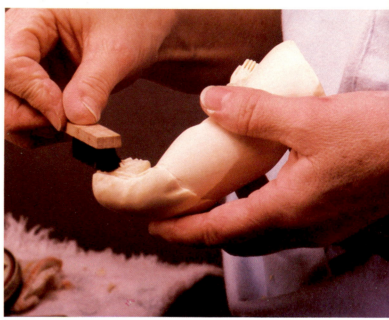

Brush the powder off again.

Apply a second coat. Repeat this sanding-finishing procedure one more time for a third coat.

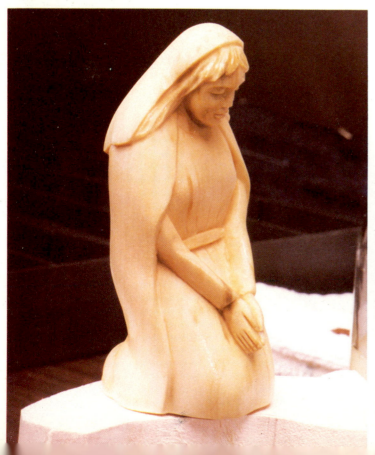

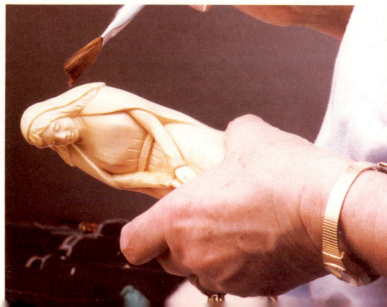

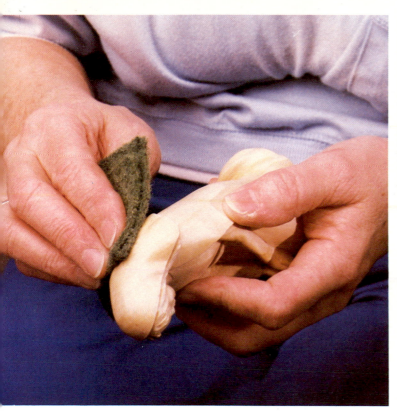

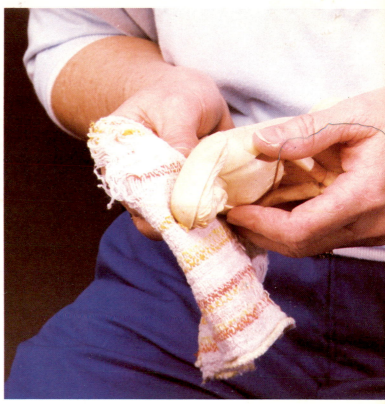

When the third coat dries I do the final rubbing. I use a product from the grocery store Scotch-Brite™. I like it a little worn, and, of course, without soap.

Apply it with a rag.

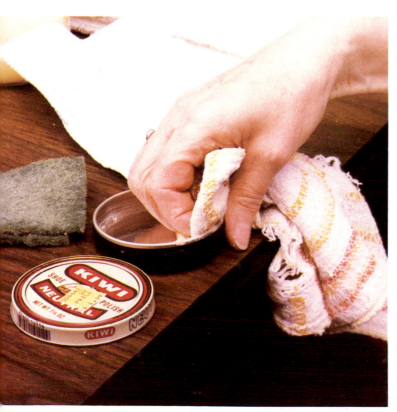

For the final waxing I use a neutral paste shoe polish.

Let it dry for about five minutes, then buff it with a soft rag.

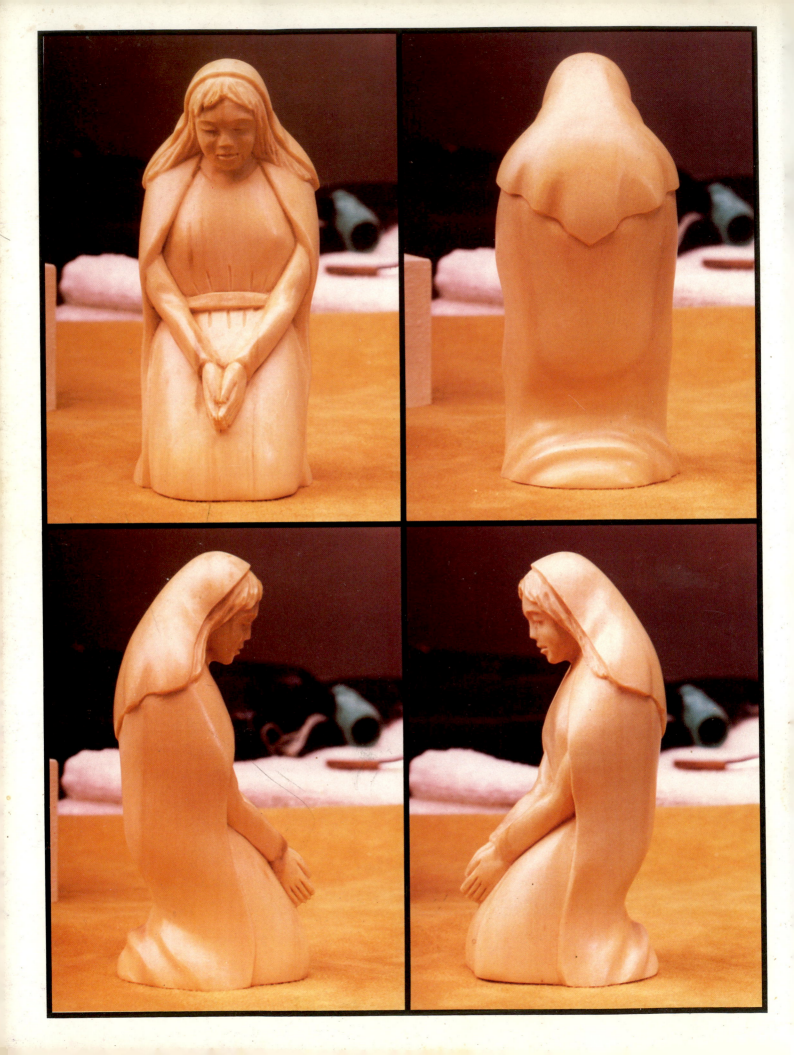

The Gallery

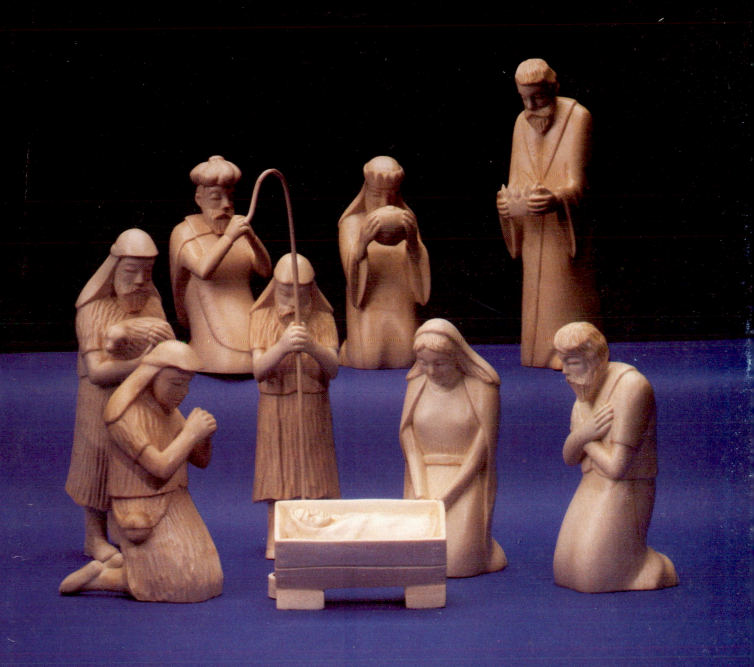

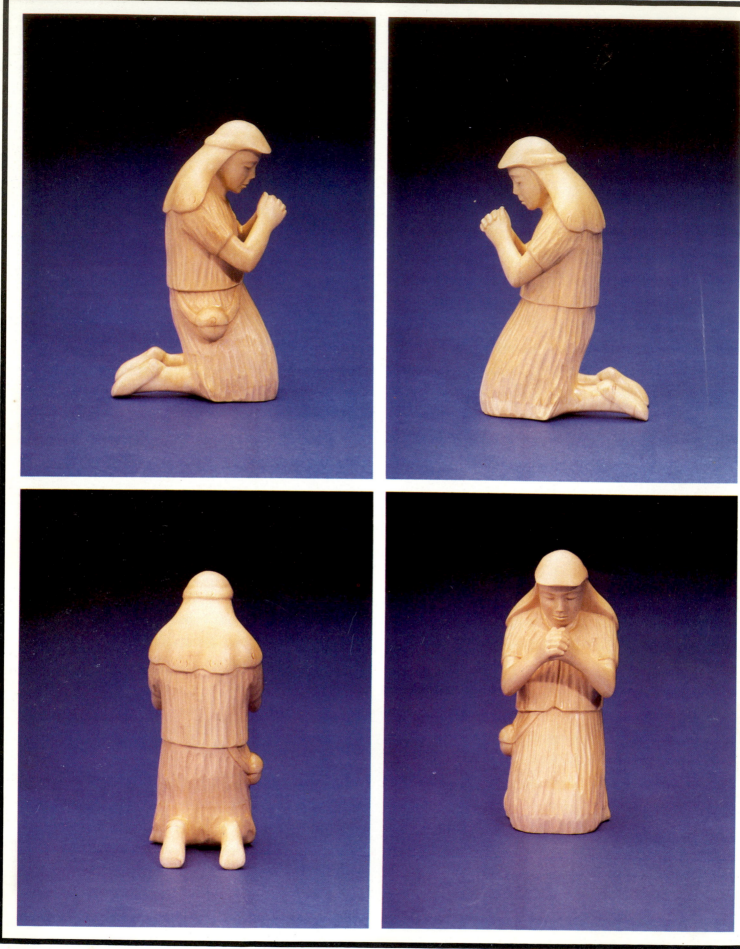

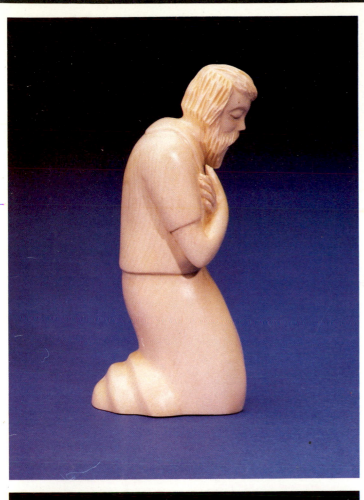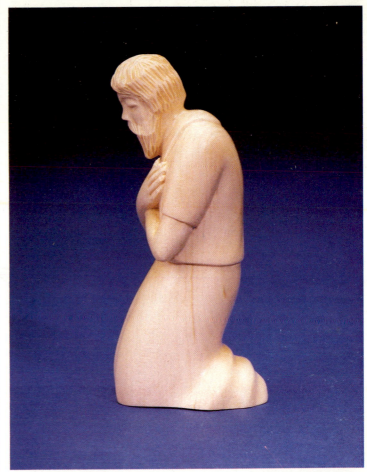

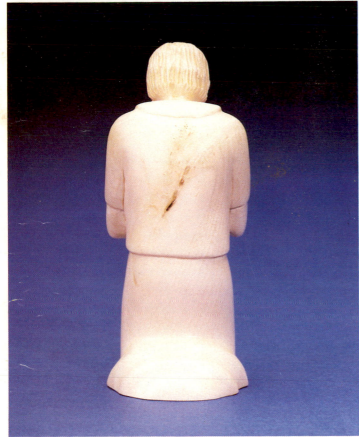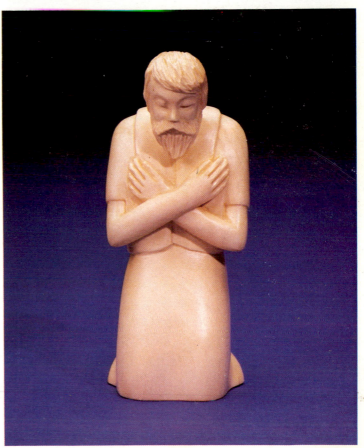

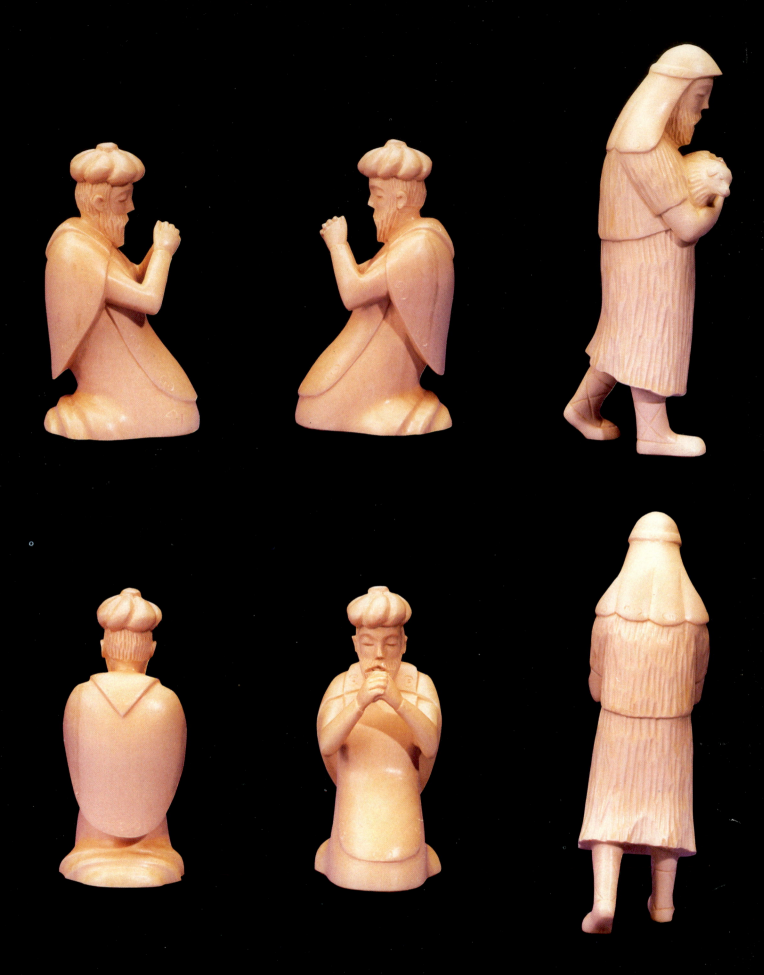

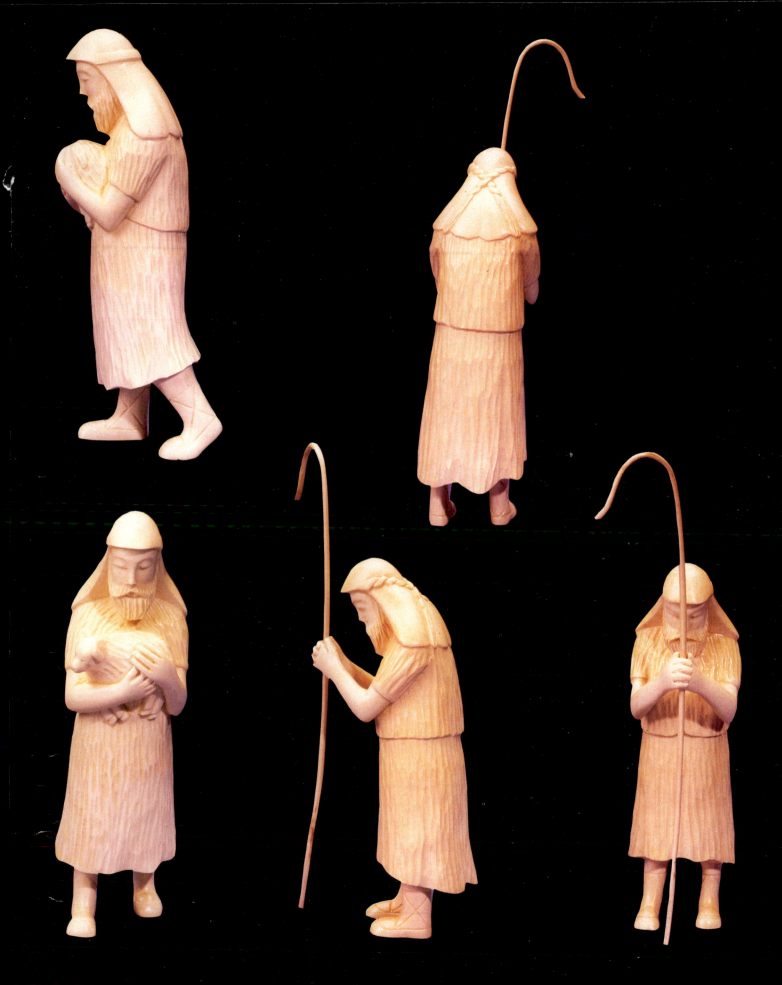

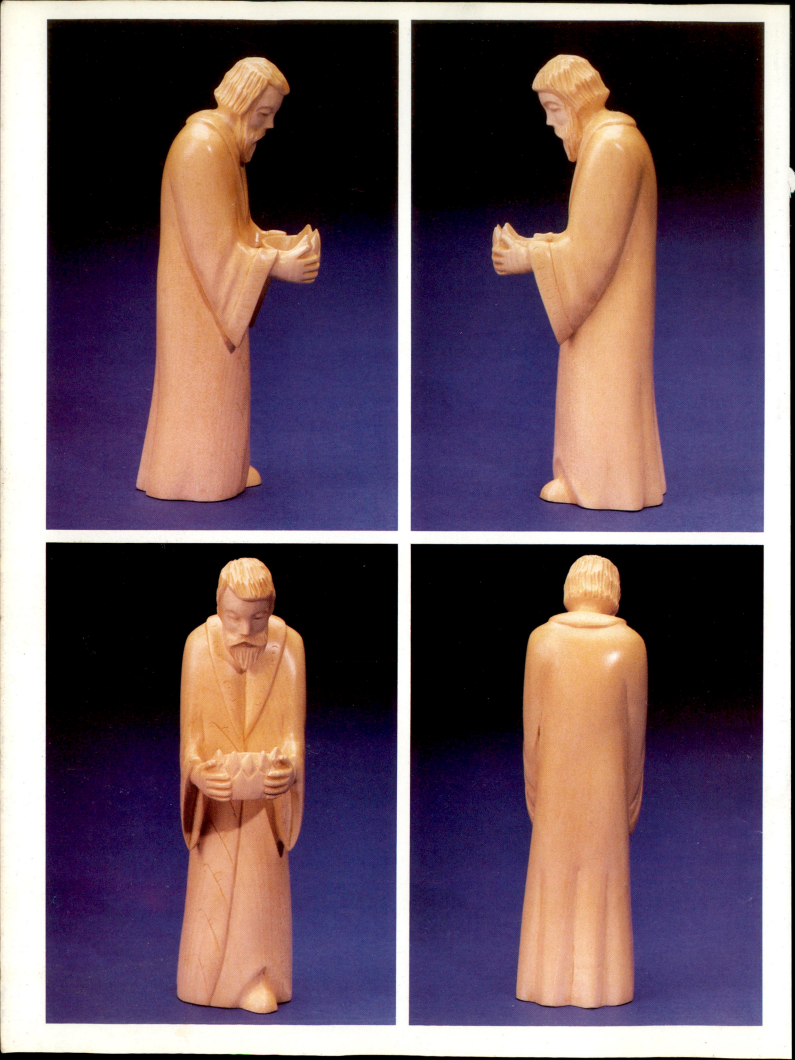

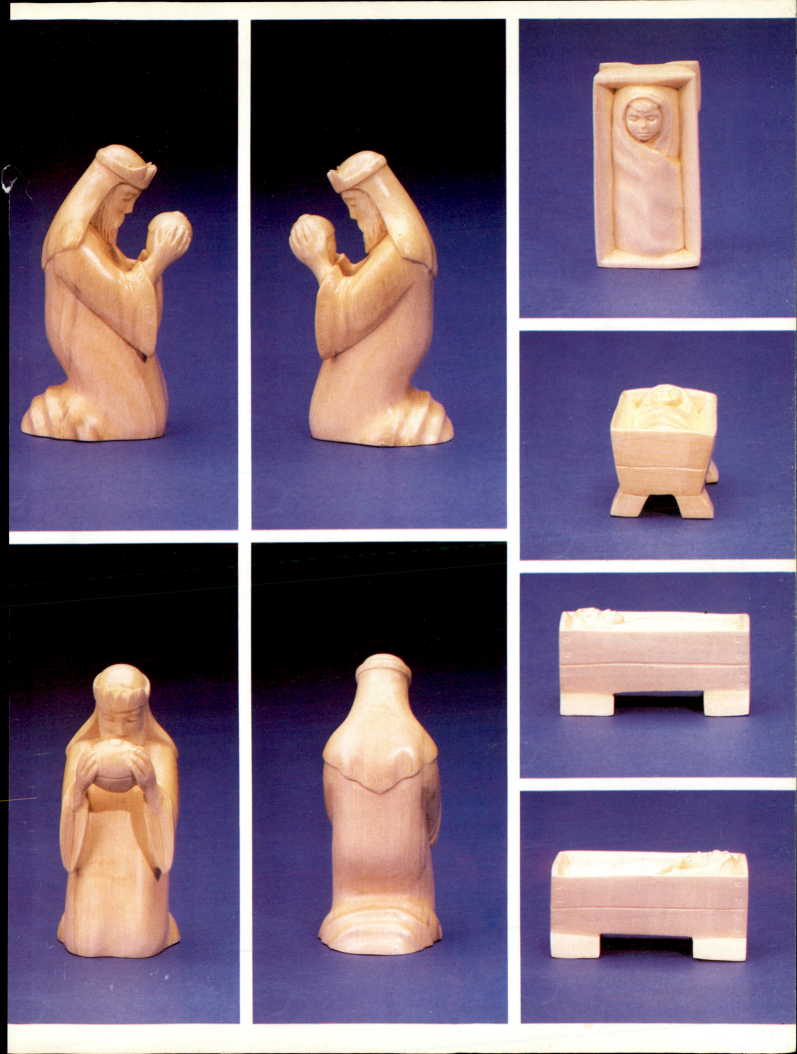

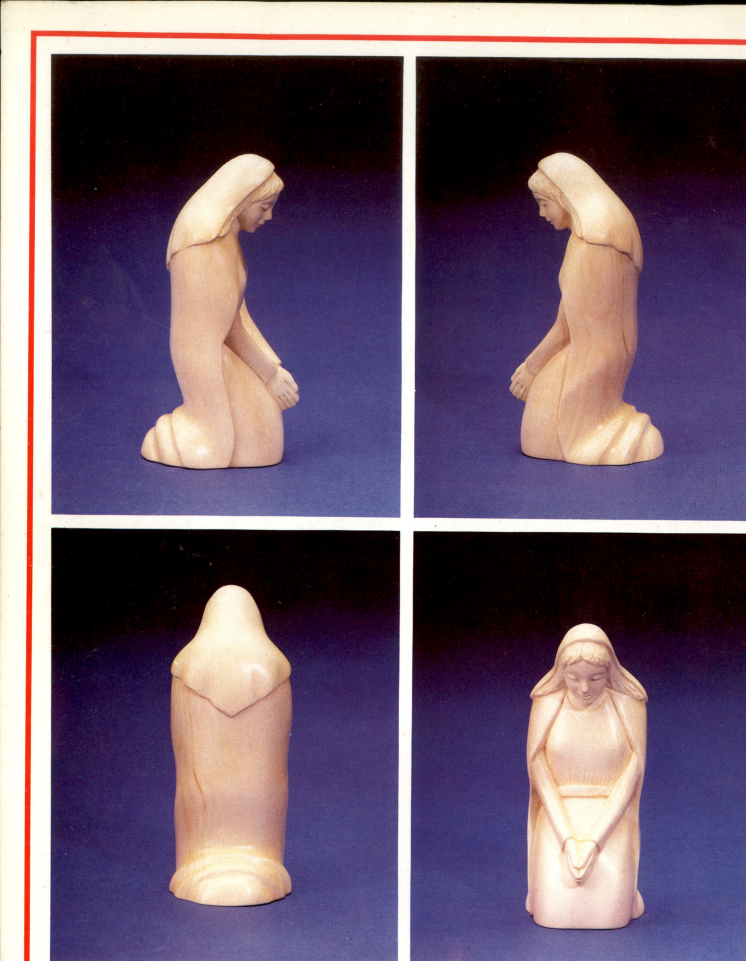